THEY DRANK TO THAT
BARS, BEER, AND THE BEAT OF HAMTRAMCK

GREG KOWALSKI

AMERICA
THROUGH TIME®
ADDING COLOR TO AMERICAN HISTORY

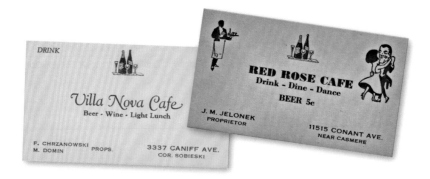

This book is dedicated to the memory of Joseph and Martha Kowalski,
who were my parents and greatest supporters.

America Through Time is an imprint of Fonthill Media LLC
www.through-time.com
office@through-time.com

Published by Arcadia Publishing by arrangement with Fonthill Media LLC
For all general information, please contact Arcadia Publishing:
Telephone: 843-853-2070
Fax: 843-853-0044
E-mail: sales@arcadiapublishing.com
For customer service and orders:
Toll-Free 1-888-313-2665

www.arcadiapublishing.com

First published 2017

ISBN 978-1-63499-039-4

Typeset in Mrs Eaves XL Serif Narrow
Printed and bound by CPI Group (UK) Ltd, Croydon, CR0 4YY

CONTENTS

ACKNOWLEDGEMENTS

This book would not have been possible without the resources of the Hamtramck Historical Museum. In addition, special thanks go to Walter Wasacz, Christopher Betleja and Charles "Chip" Sercombe for their invaluable and encyclopedic knowledge of Hamtramck's music scene. Thanks also go to Art Lyzak for his personal insight into the story of Lili's Bar, and to Mayor Karen Majewski for her input.

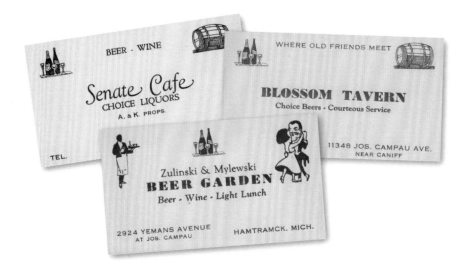

INTRODUCTION

How to you fit nearly 200 bars into a town that spans just 2.1 square miles?

And why would you want to?

The answer to the first question is easy. You put the bars on just about every other street corner and you mix in a few among the houses on the blocks. That's not hard to do in a town where the houses stand side by side on lots a mere 30 feet wide and where some 56,000 people would be crammed together.

As for the second question, well, that will take a little more space to explain—like the entire contents of this book. But you can start from the premise that bars and Hamtramck were meant to be together like a shot and a beer. Or a drunk and a jail cell. It was like that from Hamtramck's earliest days when it was founded in 1798 as a sprawling township that dwarfed the neighboring city of Detroit. But at that time most of Hamtramck was farmland and swamps. A few decades later a couple of rail lines crossed the area and Hamtramck was in the process of shrinking as Detroit grew and annexed it bit by bit. In 1901 a group of residents living in the area of the current city boundaries decided to form the village of Hamtramck. It still didn't amount to much—hardly more than a few houses, some shops and a few, well, bars.

Anthony Buhr's bar was on Jos. Campau Avenue on the South End of town. So was Munchinger's saloon, which was the hottest place in town at that time. And there would be many, many more. That was especially true after the Dodge Brothers built their factory. Dodge Main, as it came to be known, would become one of the largest factories in the world, at one point employing 45,000 workers. These were mainly Polish immigrants who came to Hamtramck to work in the Dodge plant and 22 other factories that also took root in that 2.1-square-mile town.

Polish immigrants. Beer drinking, brandy loving, hardworking souls who could tolerate the intense heat of the factories in summer—with a little help from the beer the Dodge Brothers would bring into the plant for the workers. An appreciation for alcohol would

leave an indelible stain on the town that no saddle soap could remove. Of course, the Poles weren't the only people in town. African-Americans played a key role in Hamtramck throughout its history. And there were Ukrainians, Russians and others present from the earliest days.

And the bars flourished. They were social gathering spots, entertainment venues, refuges where the lonely could find comfort and finally where the rhythm of the music would fill one's soul.

They also were gambling dens, sanctuaries for corrupt politicians and police, retail outlets for bootleggers and homes for prostitutes, all of whom operated openly before, during and after Prohibition.

This was a complex arrangement, indeed, for bars never were just places to get a drink in Hamtramck. They formed a special social fabric that helped weave the town together, for better and for worse. They weren't the only outlets people had. There were the churches, dozens of social clubs, and musical and theater troupes that didn't need or want alcohol to function. And that was fine. But they never supplanted the bars; they coexisted with them.

It was in the bars that the early politicians built their power bases—a tradition that has continued to nearly the present. You didn't have to be a member. You didn't have to act responsibly. There were no pretensions. You only had to order a drink.

As Hamtramck evolved from its raucous early days to a more mature community, the tone of the bars shifted down a few keys. Serving food became more common, as did entertainment. After World War II supper clubs and nightclubs came into vogue, and by the 1970s, the entertainment aspect exploded into a blare of punk rock guitars, hard rock songs, heartbreaking blues, dreadful (or delightful) disco and much more including some traditional polkas.

Even the alcohol changed from Kessler's whiskey to Bud Light.

But it still is alcohol and it still is there. There aren't nearly as many bars in town these days as there were in the glory days of the last century, and the new influx of Muslim immigrants in town are forbidden from alcohol.

Yet there is no sign that the bars are going to give up their cherished place in Hamtramck's history.

So let's go back to the beginning with Our Friend, the Drinker and trace this tale through his bleary eyes.

1

STIRRING IT UP

The bartender scowled. You could see in his eyes what he was thinking: *Why is this crazy Polack coming in here?*

"Well?" he said out loud.

"*Piwo*," said Our Friend, the Drinker as he slapped some coins down on bar. *Lotta nerve*, thought the bartender, *ordering beer here—in Polish, yet.*

For a moment the two men glared at each other—one deciding if he should make a break for the door, the other weighing if he should jump the bar, grab the guy by the throat and toss him out onto the dusty street. Neither would back down, but after a few tense moments, the bartender opened a bottle—of German beer—and smacked it on the bar so hard it almost broke.

Our Friend, the Drinker took a sip, made a slightly sour face and said, "not bad … for German beer." And with that he made a quick exit, still clutching the bottle.

That may or may not have actually happened, but it certainly could have. Such was the mood in Hamtramck that day in 1917. There was tension even in the bars, which for a host of reasons is not a good place for people to feel confrontational. But it was like that everywhere in town. In the past seven years, Hamtramck had gone from a sleepy farming village into a major industrial town. The transformation was staggering. The village of Hamtramck at that time was a mere 2.1 square miles and in 1910 it had a population of about 3,500 people. By 1920 the population would reach 48,000. The growth was so rapid that in 1915 the federal government did a special census of Hamtramck and determined the town was growing at a rate 50 times greater than the rest of the country.

What spurred that phenomenal growth was the auto industry, specifically the fact that brothers John and Horace Dodge opened a plant in Hamtramck in 1910. The Dodge Brothers were on a rocketing career path. They had a factory in Detroit where they were building parts for Henry Ford, but they wanted to make their own cars and compete with him. Scouting the area, they came to Hamtramck in the summer of 1910. It had a lot to

offer them. It was just outside Detroit, so it was close to the big city, but the village of
Hamtramck had lower property taxes, plus there was plenty of open space to accommodate
the factory and its future growth. And two railroad lines crossed at the south side of town,
one of which led right to the new factory that Ford had opened in Highland Park, just a
couple of miles north of Hamtramck.

The Dodge Brothers (and, please, they were the Dodge Brothers. Send a letter to John
Dodge or Horace Dodge separately and it would be sent back to you unopened) had
already established a reputation as first-rate engineers who built quality auto parts. Ford
might complain sometimes, but he knew how good they were.

In June 1910, they bought a parcel of land in Hamtramck south of the railroad tracks
and by November they were building car parts and shipping them off to Henry Ford.

That lit the industrial boiler that would power Hamtramck and forever change it.
The people living there at the time could not have imagined what lay ahead for them.
Throughout Hamtramck's history, it had been mainly agricultural.

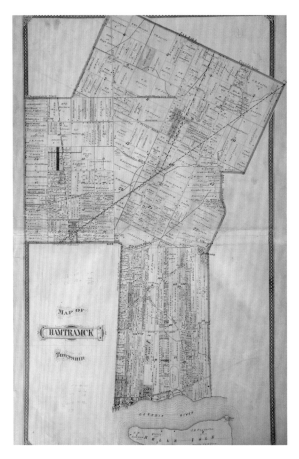

By the time this map of
Hamtramck Township was made
in the 1870s, Hamtramck had
shrunk considerably. The Grosse
Pointes had split off in 1848 and
further reductions were coming
as Detroit grew and annexed the
township bit by bit.

Hamtramck dates from 1798 when the first Hamtramck Township was formed. It originally stretched from the Detroit River to Base Line (now Eight Mile Road) and from Woodward Avenue through the Grosse Pointes. It was named in honor of Jean Francis Hamtramck, a French Canadian born in 1756 who came to the fledgling United States to fight in the Revolutionary War. Hamtramck had a bitter hatred towards the British for what they had done to his homeland in the French and Indian War. Changing his name legally to John Francis Hamtramck, he rose through the ranks as he stayed with the American army after the Revolution. In 1796 troops under his command finally took back Detroit from the British who had refused to budge after the Revolution. He had earned the respect of George Washington and when the township was formed, it was christened with his name. Col. Hamtramck died in 1803. Unfortunately, all of his possessions were in storage and were destroyed in the great Detroit fire of 1805, so if there were any portraits of him, they were gone with the flames. We don't even know what he looked like, although he is still among us. In 1962 the city removed his remains from Mt. Elliott Cemetery in Detroit and reburied him at Veterans Memorial Park in Hamtramck.

Throughout the nineteenth century Hamtramck shrank as Detroit grew. A piece at a time Detroit annexed portions of Hamtramck Township. Originally settled by French merchants and traders, they were supplanted mainly by Germans who edged farther north of the river as the population gradually moved inland. By the time the 19th century turned over to the 20th century, a settlement had been formed where Hamtramck currently is located today, about five miles north of the Detroit River. There the Michigan Central Railroad and the Grand Trunk Railroad cross paths. The area wasn't much, just a few hundred residents clustered along Jos. Campau Avenue, which became the main road in town. That was bisected by Holbrook creek, which by contemporary accounts, was fairly wide and at the bottom of a deep ravine. It was a popular spot for fishing. Roads weren't paved, sidewalks—where there were sidewalks—were made of wooden planks, and there was a horse ranch just up the road.

The downtown area consisted of a few houses, a general store, a creaky hotel, some miscellaneous shops and even a little vaudeville theater.

And some bars.

Yes, there they were. The seeds of what was to come. They were almost nothing to look at or even to be in, but they had an amazing future ahead of them in Hamtramck for they were not destined to be urban afterthoughts but rather perverse cornerstones of the community.

There was Buhr's place and Munchinger's and Ziski's and Cooper's among others.

If you were a Hamtramckan in 1900 you would know well the names of those bars and the people who ran them, for they also ran the town.

In 1900 Hamtramck Township was a patchwork of land chopped apart by the growing city of Detroit. Over the years Detroit had advanced across the metro area as it assumed huge proportions. Some hailed the robust growth of the city. Others, however, saw it as a

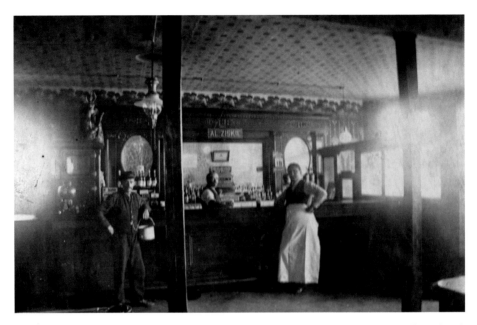

Al Ziskie's Bar was typical for Hamtramck in 1912—and even today. The basic design of bars hasn't changed much in centuries.

threat. That's how the small cluster of Hamtramckans living near the junction of those two railroads felt. Their town, such as it was, was endangered. So one day a group of residents gathered in Holbrook school and decided to form the village of Hamtramck. They staked out borders of about 2.1 square miles and petitioned the state government to permit the village of Hamtramck to be formed. The state agreed and in 1901 the village became a reality. (Incidentally, Holbrook school was still functioning as a school as of 2017—a true living link to the past.)

That new identity gave the residents a degree of protection from being swallowed up by Detroit as it became an independent, defined town. And more importantly, it reinforced the feeling of community among the residents. Now they had a home town that made sense. It was no longer part of a "township," whatever that was, and it had close borders, not some distant lines on a map and ranging far across the landscape. Now it was home. It was theirs. It was ready to fight Detroit if it infringed on Hamtramck's borders. It was ready to establish its own local government, it was even ready to build real sidewalks and install urban amenities like sewers.

The only thing it wasn't ready for was what actually happened to it. But that was still a few years away.

For now, the folks were content to tend to their crops, fish, hold picnics and deal with the matters of making a village work. In the first village election held August 26, 1901,

F. Anson Harris was elected village president; Henry Jacobs, clerk; H. Krause, assessor; J. Heppner, treasurer; and W. Hawkins, E. Oehemke, H. Mueller, J. Segrist and J. Berres, trustees. The first meeting of the village council was held August 29, 1901, in a house located at the southwest corner of Denton Street and Jos. Campau Avenue, which was leased at a cost of $100 a year.

Looking over the minutes of the early village board of trustee meetings can make one wonder why they even bothered to become a village. They dealt with such pressing issues as installing wooden sidewalks ("Good pine, hemlock or Norway plank of uniform thickness, planed on one side, not more than eighteen inches nor less than five inches wide, laid not more than one-quarter inch apart on three rows of cedar, pine or hemlock sleepers, not less than four inches square, and the outside of the sleepers to be not more than five inches from the end of the plank.") and streetlamps that would throw pale arcs of light below them. Alas, almost as soon as the streetlights went up they became the targets of sharpshooting youngsters who took such good aim at them that the village council offered a $5 reward for each vandal who was caught. Installing water and sewer lines also would occupy the village council for several years. Another issue was hiring someone to draw up maps of the new village.

In about 1905 Holbrook Creek was channeled into sewer pipes and buried underground. And talk of paving the streets and even the alleys began to surface.

St. Florian was founded as a Polish Catholic parish in 1908 in anticipation of the growth of the Polish population of Hamtramck. It would become a cornerstone of the community and a counterpoint to the also increasing number of bars.

In 1908 a significant addition was made to the community with the founding of St. Florian Polish Catholic Church. Through mainly the second half of the nineteenth century, Poles began settling in Detroit. The core of the Polish community was the area of St. Aubin and Canfield streets in Detroit, about three miles from the river. This is where St. Albertus Parish was founded in 1871. The area was to go through a raucous history of its own as warring factions within the parish led to rioting and even the death of one man. Media coverage of the conflict led to the area being dubbed as "Poletown," referencing the large Polish population there. The conflict was eventually settled peacefully, but it did draw attention of the Detroit archdiocese, which took note of the growing Polish immigrant population there. Logically concluding that more Poles were coming and they would settle in the open areas north of Poletown, the archdiocese officials came to Hamtramck and asked local residents if they would like to have a Polish parish located in the village since more Poles were likely to move there.

Hamtramck's population was largely German at that time, but there were enough Poles in town to give the idea their blessing and so St. Florian was born. It would eventually become the second largest parish in the Archdiocese of Detroit. And more importantly, it—along with the coming Dodge Main factory—would form as the most important cornerstones of the community. That would play a major role later as that third cornerstone—the bars—would rise to an amazing prominence in town. But St. Florian dealt with spirits of another kind and would provide a counterbalance to the bars. First Masses were held in a storefront on Jos. Campau Avenue, but soon a section of land was donated to the parish and a combination school/church building was constructed in 1909 (also still in use as a school as of 2017). In its time it was quite an impressive building that would rival the growing number of factories that were going to spring up.

But let's pause here, as our Friend, the Drinker sits on the stairs of St. Florian Church, taking in the June sun in 1910. The bottle of beer he has is just as warm as the day and he sees nothing improper in nursing a beer at the door of the house of God. Several questions occupy his thoughts. Where was his life going? Where was the town headed? By now everyone had heard that the Dodge Brothers had just bought a big piece of land on the other side of the railroad tracks and they were going to build a factory there. Perhaps he could get a job. There wasn't much else for him to do around the place now. He wasn't a farmer, so he did handy work and picked up whatever job he could. It didn't pay much but it didn't cost much to live there either. And beer was cheap. So he could scrape by.

What he didn't realize was that in a matter of a few weeks his life was about to change, as was everyone else's in Hamtramck. As soon as the Dodge Brothers closed the deal on their land buy they began construction of the factory. They already had a plant in downtown Detroit (right around the corner from where the Greektown casino would rise nearly 90 years later) but it was too small to meet their ambitious plans. By November of 1910 the plant was functioning and shipping parts up to Henry Ford's Highland Park plant just

When industry came to Hamtramck in a big way in the early 20th century, it transformed the community into an uncomfortable mix of factories, houses, schools and stores—and bars.

to the northwest of Hamtramck. That plant, too, provided employment opportunities to Hamtramckans, but unlike Henry Ford, the Dodge Brothers had no interest in structuring the private lives of their employees. They didn't care about the morals of their employees, as Ford did. The Dodges just wanted them to build car parts. Actually, they wanted them to build cars, for that was their real aspiration. Although they were part owners of Henry Ford's empire, the Dodge Brothers planned on becoming competitors of him by producing their own cars. It wasn't an idle dream. By this time the Dodges were recognized as expert engineers and had a reputation for quality. When they were ready to start production of cars in 1914 they were flooded with thousands of requests from would-be Dodge dealerships across the country. They were taken seriously by consumers and auto makers.

And they knew about the quality of others. Early on they hired noted architect Albert Kahn to design the beginnings of their factory and they were quick to get production started.

With their factory already humming, the Dodges put out a call for new employees. That was answered in a way that no one could have predicted. Suddenly thousands of wannabe workers appeared. And for reasons that are still not clear, the vast majority of them were Polish immigrants. Some had come straight from Poland. Many others had settled elsewhere in the United States, including Pennsylvania where they worked in the coal mines. Work there was especially dangerous, so when the opportunity to work above

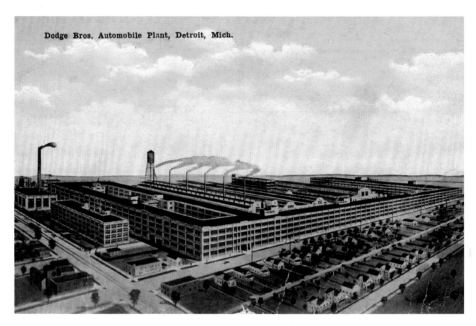

Modern Hamtramck was born with the establishment of the Dodge Main factory 1910. It grew to become one of the largest factories in the world and was the economic power house of Hamtramck for decades.

The elevated track on the north side of the early Dodge plant tested the engineering of the cars. They passed. Sales of Dodges soared, fueling the expansion of the factory.

ground surfaced they headed for Hamtramck. With the rapid expansion of the Dodge factory, nearly two dozen other factories opened in town. The majority of them, like the Briggs plant, serviced the auto industry. In 1917 the Chevrolet factory was built straddling Hamtramck's western border with Detroit. Although dwarfed by what Dodge Main would grow to become, it was still a major operation.

During this same period, the huge Packard auto factory was built on East Grand Boulevard, just a short distance from Hamtramck. Also, Albert Kahn designed the Murray Auto Body complex spanning some two million square feet of space on Clay Street, also just across the border of Hamtramck. These all didn't come up at once: Henry Ford's Highland Park plant, Dodge Main and the Packard plant opened in 1910; the Murray plant was built beginning in 1916 and Chevrolet factory opened in 1917. And there were other industries. The Acme White Lead plant was a pioneer in Hamtramck, opening in 1893. Champion Spark Plug started as did Palmer Bee, Swedish Crucible, American Radiator Company, Michigan Smelting & Refining Company and more.

Together through a short span of years they formed a powerful industrial magnet attracting workers. The result in Hamtramck was staggering. Hamtramck's yearly population growth looked like a steep staircase with the numbers rising at an astounding rate. As noted earlier, in 1910 there were about 3,500 people living in the 2.1-square-mile village. That would rise to 48,000 by 1920. In 1915 the Federal government did a special census of Hamtramck and neighboring Highland Park, which also was experiencing a phenomenal growth, although not as great as Hamtramck. In the case of Hamtramck the census noted that the town was growing at a rate of 50 times greater than the rest of the country. That made news across the nation.

The Commercial, a newspaper in Union City, Tennessee, more than 600 miles from Hamtramck, carried a front-page story on its August 13, 1915, edition entitled "Automobile Business Transforms Village." It noted:

> Striking evidence of the prosperity of the automobile industry is revealed by the recent action of President Wilson in ordering a special census of the village of Hamtramck, Michigan.
>
> Eugene F. Hartley, an official of the Census Bureau, has just completed his task, and his record shows that since 1910, when the last census was taken, Hamtramck has enjoyed a 504 per cent increase in population.
>
> In 1910 the population was 3,559 and the recent census shows that 21,242 people now reside in the limits of the village. Government officials say the cause for the big increase in population is due to the automobile business. Hamtramck is situated just to the northeast of Detroit and contains the huge plant (of the) Dodge Brothers. At the time Dodge Brothers commenced the manufacture of motor cars, they employed under 3,000 men. Today the number is well over 9,000 with facilities under way that afford employment for many more men.

The Sentinel of Yuma, Arizona, over 2,000 miles from Hamtramck, in its July 15, 1915, issue noted Hamtramck's development, concluding with "Its remarkable growth is due in great measure to the presence of large automobile factories within and near its borders."

The January 9, 1916, edition of the Washington, D.C., *Sunday Star* reported:

> How the phenomenal growth of the automobile industry in the last five years has operated to move masses of people across the country and to make villages into cities is brought out by the fact that three of four requests that the census bureau has granted during its existence to make special enumerations of towns in urgent need of the truth about their populations have been about one of the country's greatest manufacturing centers. All of the special censuses have been taken during the past year and have shown the greatest percentage increases in the history of the country.
>
> The first of the automobile group to make application for a between census count was Hamtramck, Mich., a suburb of Detroit, which has large automobile and automobile parts factories in its boundaries ...

Cars were making their mark on the landscape, especially in Hamtramck. While the factories provided a steady source of income, although that amounted to about $2 a day (at least until Henry Ford came along in 1914 and upped the bar to $5 a day), the work was often miserable with accidents and deaths occurring on a regular basis in the plants. There was no air conditioning and temperatures could soar well above 100 F on a summer day. Sometimes conditions became unbearable, leading to worker walkouts, although that was a risky proposition especially in non-union shops. If you were lucky you got a job in the Dodge plant. The Dodge Brothers actually did seem to care about the workers, providing benefits for the families of workers accidentally killed in the plant. And the legendary tale of them bringing beer into the plant during the hot days for the workers is true. No wonder the plant's thousands of workers were sent into stunned silence twice when both brothers died several months apart in 1920.

Of course, the Dodges weren't looking out for the workers' welfare when they toted beer into the factory. They just didn't want the workforce sneaking out the backdoor to the nearby bars to get their drinks. At least the Dodges could control the flow of booze within the plant. Outside, it was another story that mirrored the swift growth of the factories.

Surrounding the factories, in fact, often right next door to them were thousands of modest wood frame houses that were being thrown up by enterprising builders at a furious pace. Whole neighborhoods were being created almost overnight as the remaining fields, forests and open spaces that once characterized Hamtramck were churned under and gouged out to create the foundations of a burgeoning urban center. To maximize space, houses were built mainly on lots 30 feet wide by 90 to 100 feet deep. The distance between neighboring houses was usually no more than five or six feet. Multiple family homes were

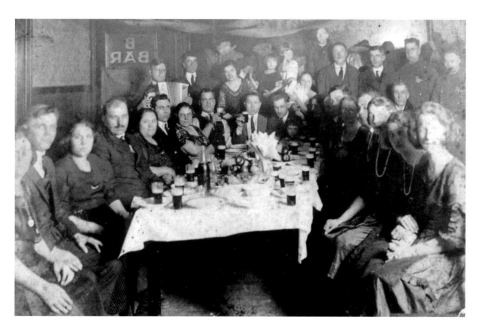

This gathering at B Bar included women and even an accordion player. There's no record of what the occasion was but it must have been quite special.

common, often with one family living upstairs and one downstairs. In some cases, homes were divided into clusters of rooms with two sets of three rooms on the first floor and two sets on the second. It was typical for families to have five or six children at that time so one house might host 20 or more family members. And houses were stacked next to each other, row after row, block after block.

Living conditions were fairly dreadful. When you bought a house during this time you generally got cold running water and electricity. No furnace, no insulation, no hot water heater, no bathroom. However, there was an outhouse in the barn at the back of the yard. During winter people often closed off whole sections of their home to contain the heat drawn from wood, and then later coal, burning stoves. As for the outhouse on a cold winter's night, one can only shiver at the thought today.

Oil burning furnaces and indoor toilets came along in the 1920s and 1930s. It wasn't until the early 1950s that the last outhouse in town was replaced by an indoor toilet. In fact, the city was shocked when the 1950 U.S. Census showed that at that time there were 64 houses in town that had no indoor toilets. Also, 1,127 did not have any hot water and four had no running water at all.

So life was no picnic for the average factory worker. Sure, it was still a lot better than what most immigrants left behind in the Old Country, and few returned there, but it was still was challenging, especially for those raising a family.

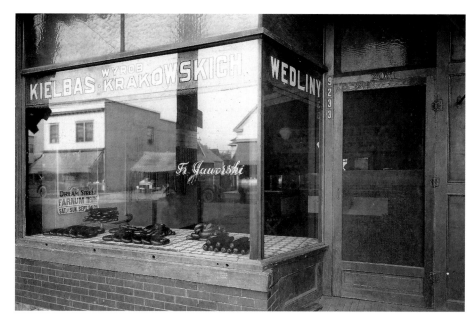

The Jaworski sausage company was typical of the Polish businesses that began to appear in Hamtramck following the opening of the Dodge plant in 1910. The poster in the window helps date this picture to 1921, the year that D. W. Griffith directed the film "Dream Street."

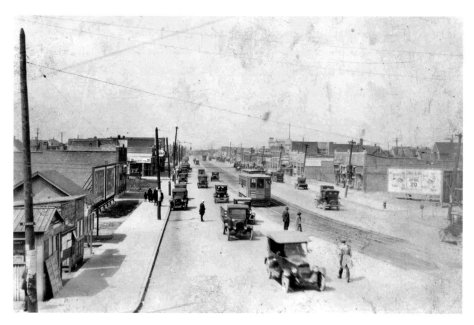

Jos. Campau Avenue looking north of Caniff was still relatively sparsely populated in the early teen years of the 20th century.

Those factors were key to the explosive appearance of the bars that took place in the "teen" years growth spurt of the town. Bars certainly predated this period and at least some were well established in Hamtramck before it even became a village. But with so many people pouring into town the demand vastly increased. Remember, these immigrants were working class folks who cherished their drinks going back centuries in the Old Country. Beer, vodka and brandy were particular favorites and they were in great demand especially by the workers who toiled at often grueling jobs in generally deplorable conditions. And life at home had its own challenges, with usually many kids to feed, rent to pay and all the miscellaneous costs that needed to be met. You might be able to filch some lumps of coal from Mistele's coal yard on Jos. Campau Avenue once in a while, but that wasn't going to keep the house livable when it was near zero outside on a Michigan winter's night. And at this period, there was virtually no social net for the poor. The Tau Beta Community House on Hanley Street often could help by providing legal assistance, some health care and language assistance for immigrants who had a problem but couldn't speak English. Tau Beta even started the city's first public library and offered at least some day care services for working moms. But major problems, especially financial ones, were an ever-present threat to their meager quality of life. These would intensify greatly during the Great Depression when the unemployment rate would reach a staggering 60 percent, but that was still years away. This was still boon times, when jobs were plentiful. Yet that didn't ease the strain of day to day living.

But the bars did—at least while the glow of the alcohol lasted. Brewers and bar owners were quick to sense the potential market, especially as the population expanded. In 1914 alone eleven persons applied for liquor licenses: Anthony Budnick, for his place on Jos. Campau; John Czekai who was on Edwin Street; Ignatz Falkowski, on Holbrook Avenue; John Zielinski, on Andrus Street; Joseph Rybicki, also on Jos. Campau; Michael Kluczynski, on Lumpkin Street; Steve Kowalski, on Caniff Avenue: John Sarossy, on St. Aubin Street; Frank Stasiniewicz, on Conant Avenue; Frank Stieber, also on Edwin Street; and Joseph Stocker on Conant Avenue.

Ed Lezuchowski's name isn't among those mentioned above, as his bar came into being just after Prohibition, but it reflects well what the bar scene was like before everything went dry.

"People worked hard in those days," Lezuchowski said in an interview recorded in 1999 in his place, Norwalk Bar, on Conant Avenue when he was 73 years old. Norwalk Bar was a quintessential shot-and-a-beer bar. There were few amenities but lots to drink.

"(The workers) couldn't survive without a booster," Lezuchowski continued. "They'd line up at seven o'clock in the morning to get a shot and a beer and go to work at Dodge Main (just down the street from Norwalk Bar), or anyplace. Plumbers, carpenters. We had a bunch of plumbers next door, and they'd line up at seven o'clock in the morning. That was their breakfast. But they had to because they worked very, very hard."

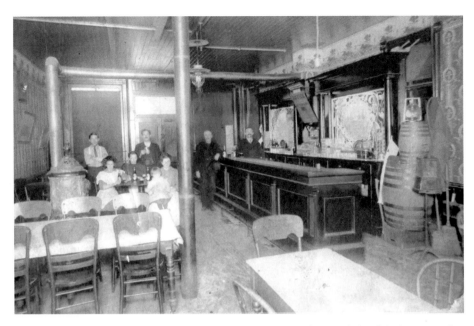

Renee Van Eeckhoutte's bar on Jos. Campau Avenue in 1909. That's Renee behind the bar. His wife is holding their child at the table. The bar was later demolished to make room for the Dodge Main factory.

Norwalk Bar was a family operation started by Lezuchowski's father and godfather. "My godfather was building the bar when customers were coming in. It was that way. People helped each other out. You didn't really hire somebody to do the job. You did it yourself and somebody helped you."

Hamtramck was different in those early years when he was a boy. The town was a lot more crowded "and they were all poor," Lezuchowski said. "They came from the Old Country. My mother came from the Old Country." Many worked at Dodge Main, and it was not unusual for three men to sleep in the same bed, each taking turns while the others were working a different shift.

Lezuchowski grew up in the bar, but after serving in World War II he went to the University of Detroit and got a degree in mechanical engineering. He was working for Burrough's Corporation when his mother died in 1961. From the time he was 21 years old she had been insistent that he would inherit the bar and run it. Lezuchowski recalled that in 1946 he hooked up the bar's first neon sign. As he stood on the sidewalk across the street from the bar with his mom and a customer flipped the switch lighting the sign for the first time, she said to him, "This is for you, Son." Those words came back to him when she died.

"Her words stuck with me and I'm here and I'm glad I made the move because it was the right decision," he said. Norwalk Bar later closed and found new life as a pharmacy, its drinking days apparently over for good.

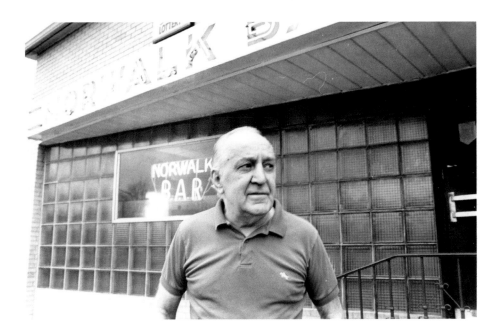

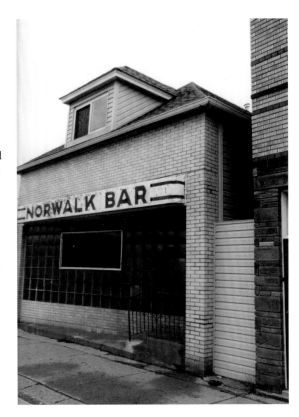

Above: Ed Lezuchowski operated Norwalk Bar on Conant Avenue for many years. It was typical of Hamtramck's earliest bars in its basic shot-and-a-beer offerings.

Right: Norwalk Bar was a throwback to the days of the workingman's basic bar. It catered to Dodge Main workers who would stop there on their way to the plant in the morning and going home in the afternoon.

Lezuchowski is a solid Polish name. So were the names of the majority of those who applied for liquor licenses back in 1914. And indeed through the years Poles would come to dominate the bar scene, but they never entirely owned it. There would be a few bars and clubs that catered primarily to African-American patrons. And the Ukrainian club stood for years on Grayling Street. But these maintained a low profile in the city, seldom attracting attention.

But in the early days of the 20th century, the focus was heavily on the German bars and the rise of places that catered mainly to Polish immigrants, especially as the Polish population began to supplant the German majority. The scales were rapidly tipping toward the Polish tipplers, and this did not please the Germans in the slightest. They would fight back in a host of ways, like trying to suppress Polish voters in local elections, infuriating them in the process.

And that is what led Our Friend, the Drinker to brazenly stride into the German bar and order a *piwo*.

2

POLITICS AND PINTS

The blurry battle lines had been drawn, in a way they had been defined centuries earlier. The Germans and Poles had been traditional adversaries in the Old Country. This was particularly evident in the late eighteenth and throughout the nineteenth centuries when Poland was basically eviscerated by Prussia, Russia and Austria, although trying to sort out all the players who got involved (like the German Confederation) is a challenge not worth exploring here.

Suffice it to say, Poles preferred the company of Poles, at least when it came to fellow immigrants. The simmering tension between Germans and Poles in Hamtramck took some time in rising to a boil. In the 1890s the area that would become the village of Hamtramck was itself a thriving little community mainly settled by Germans, although some Poles were already present. The community centered on the area of Jos. Campau Avenue near where the viaduct is today. There were a handful of businesses along the strip of Jos. Campau Avenue including several bars mostly owned by Germans. These were not only social gathering places; they became the centers of politics in what would become the village of Hamtramck in 1901. The beginnings could be traced to the formation of the Five Spot Social Order of Indians, which originally started as a social club inspired by an Indian show of the traveling Wild West kind that once was popular. In around 1890 some Hamtramck friends witnessed the "Indians" at such a show staging a performance, including a "war dance." The Hamtramckans were so impressed they decided to form their own tribe and put on their own shows in Hamtramck. They established a club headquarters in a barn on Jos. Campau Avenue where the gate of the Dodge Main factory would stand in later years.

The original members were Anthony Buhr, Ed Russell, R. Hening, E. Gill and Henry Jacobs. After creating their act and rehearsing it in the barn, they were ready for their first public performance, which would be held at Cooper's saloon at Jos. Campau Avenue and Clay Street. According to E. R. Rarogiewicz, writing in the 1947 Hamtramck Yearbook, "Without an announcement they appeared in full Indian regalia, with tomahawk and all, threw a lighted

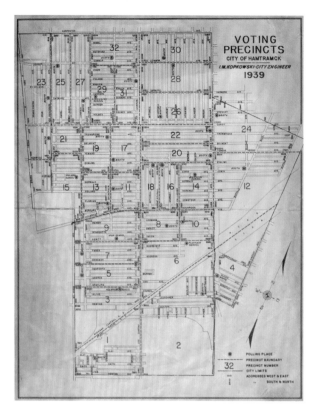

By 1939 Hamtramck was divided into 32 voting precincts. It was reflective of the large number of voters in the city. Hamtramckans took voting seriously. It was not unusual for an election to have a 90 percent or better voter turnout.

box of matches on the floor, and to the amazement of the saloon's 'stammgasts' began to dance around the fire. It drew live applause from them, encouraging the Order of Indians to continue their efforts. Shows given in other saloons, dance halls, picnic grounds, etc., met with approval and success. From now on Cooper's place became their headquarters."

There are two things to note in Rarogiewicz's account: One is his use of the word *stammgasts*, which is a German term to denote bar patrons, and the other is the fact that a saloon became the club's headquarters.

In a few years the Five Spot Social Order of Indians faded away, but it did provide the foundation for the creation of another Indian-themed social club, the Hamtramck Indians, which took on a much more prominent role. But leading up to that, at around 1901, a group called the Immortal Sixteen was formed. This consisted fifteen saloon keepers and one grocer, including some of the town's most prominent citizens, among them being Charles Faber, William Munchinger, Joseph Chronowski and Henry Jacobs.

"It was more of a political club formed to guide the affairs of the newly created village of Hamtramck," Rarogiewicz noted. On a Sunday in 1902 the Immortal Sixteen were invited to play a game of baseball in Fraser, Michigan, north of Hamtramck.

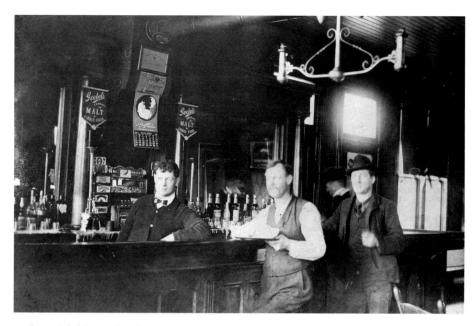

Anthony Buhr's bar on Jos. Campau Avenue was a popular spot and Buhr was active in the community as a member of the Five Spot Social Order of Indians social club and as a trustee on the village council.

"Since all were of the guild of saloon-keepers and grocers, food and drink were in abundance and a gay atmosphere prevailed throughout the escapade," Rarogiewicz wrote. On their way back to Hamtramck the Immortal Sixteen decided to increase their number when 25 persons indicated they wanted to join. That required a name change, and Ed Russell, "in the spirit of the old Five Spot Social Order of Indians suggested 'Why not call them the Hamtramck Indians,' which title was enthusiastically agreed upon and so Hamtramck Indians it came to be," according to Rarogiewicz.

Like their predecessor club, the Hamtramck Indians met above Cooper's saloon where "political topics" were predominant, for "the Indians were the ones to give the leading tone to the affairs in the village of Hamtramck," Rarogiewicz wrote.

The Hamtramck Indians would play a role in the city for many years before disbanding in the 1970s. They soon dropped their political connotation and focused on charitable activities, but at least in the beginning they helped form the village of Hamtramck and likely started the concept of saloons as serving as centers of political power. In fact a common saying bandied around town at the time was "Our five trustees are our five saloon keepers."

This tradition, to one degree or another, would carry on long after the German saloons closed their doors and the *stammgasts* left. In 1927, a publication entitled "The Wide Open Inland City" noted: "One must also remember that Hamtramck was not always the community into which it latter developed. Originally, the section lying northeast of

Munchinger's saloon on Jos. Campau Avenue near where the viaduct stands today was one of the centers of political power in the early 20th century.

the Big City (Detroit) was occupied by German truck farmers, and the inhabitants of the village, some of whom even then, were of Slavic extraction, were governed by German saloon-keeper politicians."

Perhaps the key German saloon was Munchinger's. Located on Jos. Campau Avenue near Denton Street at the end of the Baker Street Car line where the viaduct is now located, it figures prominently in references to early village days. Proprietor William Muchinger, in fact, was one of the original "Immortal Sixteen" as noted above. A fairly modest wooden structure, it was typical of Hamtramck in its early village days. It did not fit the image of a center of political power and the site it surveyed was little more than a collection of ragged buildings clinging to the sides of a dirt road. But to those there it was a palace, at least in terms of its importance in town. It was at the heart of an area that had all the makings of a little kingdom. Outside of Detroit, yet right next to that growing metropolis, it offered space to grow and low tax rates to make it attractive. Yet it wasn't so big as to be unmanageable. It wouldn't take much to control the base of power, and Muchinger and the other saloon keepers knew that.

It isn't clear just how much power Herr Munchinger directly wielded in the village for his name doesn't turn up in official village records except regarding liquor licenses. But even incidentally there was a connection. His bartender, John Jaehns, was elected village treasurer in 1918. Jaehns had come to Hamtramck in 1908 and got a job at Munchinger's

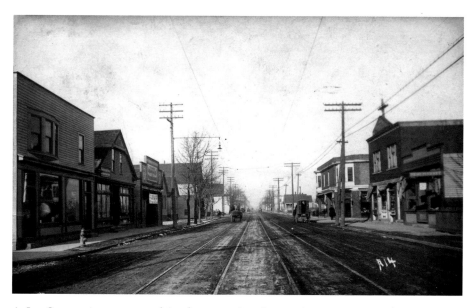

As Jos. Campau Avenue was evolving from a rural road to a major street it attracted an assortment of businesses mixed with homes along its length. That also included a vaudeville theater (at left) and several bars.

as a bookkeeper and bartender. He also met Munchinger's daughter, Marie, and ended up marrying her. Jaehns also had the distinction of being the first Hamtramck treasurer to mail out tax bills. He also opened a confectionery store on Jos. Campau Avenue, which operated at least until the 1950s.

Did his position at Muchinger's help him get elected village treasurer?

There's no way of knowing today. Munchinger's is long gone as is anyone who went there. But there is no denying that over the coming decades bars would be used as a conduit to the voting segment of the general public by a number of politicians.

The involvement of Hamtramck politicians in bootlegging during Prohibition is legendary and will be explored in greater detail in the next chapter of this book. But that's not quite the same as building a base of support at the bar rail. For one thing, using a bar to further one's political career is legal, moral and, as far as anyone knows, non-fattening. Bootlegging was a passport to prison, although it certainly did not hurt any Hamtramck politician's career. But in a way it all made sense. If you are a bar owner you will develop a series of regular customers who are going to become your pals. Chances are they will support you in whatever you do, and those chances improve greatly if you dole out some free beer or extend their credit. Sound a little shady? Well, just what aspect of politics isn't tinted by shade, whether it means accepting "campaign contributions" or treating your pals to a brew or two? Another way to look at it was as an opportunity to advance one's agenda to do good for the community.

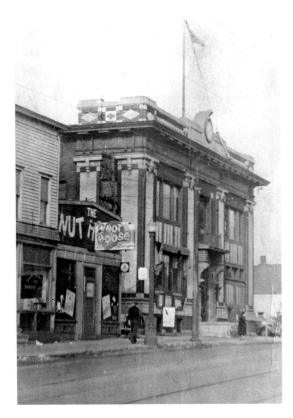

The Nut House was one of Hamtramck's most colorful bars. It was littered with humorous signs and promoted itself with bizarre postcards. Interestingly, it was located right next to village hall on Jos. Campau Avenue.

Following Prohibition, which ended in 1933, bars reappeared on the streetscape with a flourish, and the political scene remained as wild as ever. During a typical election season there may have been as many as 90 candidates running for mayor, clerk, treasurer, the five council spots, two judgeships and a handful of lesser positions such as constable. Political rallies were held literally by the dozens, sometimes several a night, at venues across the city. They could be free-wheeling events with music, speeches, brawling and beer.

Our Friend, the Drinker attended many, as the rallies were little more than big, noisy parties where there was a chance to get some free beer. With so many held by competing candidates, he didn't know who to vote for. But he didn't really care.

A popular place for rallies was the various halls around town such as the Polish Legion of American Veterans hall on Holbrook Street at the corner of McDougall Street. The hall was built in 1925 and featured a second story auditorium that could host a variety of events. The first floor included an impressive bar. This site was used into the 21st century for political rallies. And from the earliest days, the booze flowed freely there.

Vincent Sadlowski was appointed to the common council 1947 to fill a vacancy and won election in 1948, garnering enough votes to become council president at the regular

election later that year. He also was the proprietor of the Imperial Bar and in newspaper ads for the bar he announced that he was "An outstanding public servant of Hamtramck."

In later years, Joseph Piasecki, better known as "Shy" operated Shy & Red's, a bar positioned near the Chevrolet Gear and Axle plant on the city's west site. It was ideally located for capturing the workingman crowd (much to the chagrin on the Chevrolet management, which didn't appreciate tipsy transmission toolers returning from lunch each day) well into the 1980s. He also served on the school board for more than 20 years.

Vasil Vasileff owned Vasil's Bar and the Jungle Show Bar. In the early 1960s he served on the common council and also was deputy DPW superintendent.

More recently Cathie Gordon served on the common council in the 2000s. She's the owner of the classic New Dodge Bar on Jos. Campau Avenue. It's a historic place, complete with a Prohibition-era tunnel visible below the bathroom floor. You can see it through a plastic sheet installed in the floor.

Bob Kozaren was one of the most successful politicians in Hamtramck's history. Looming large on the political scene, he stood about six feet seven inches and played basketball on the local courts with such greats as Rudy Tomjanovich, who went off to find fame with the Houston Rockets.

Kozaren served as a deputy clerk before running for mayor in 1979. He won and went on to serve a record eighteen years in office. It was a remarkable political career that encompassed a host of great successes, like playing a key role in bringing the General Motors Detroit-Hamtramck Assembly plant to Hamtramck. That was vital in rescuing Hamtramck from almost certain financial ruin, for when the Dodge Main plant closed in 1979 it deprived the city of about one-quarter of its annual operating tax revenue. That was a huge blow and there was no way visible at the time to replace it. Kozaren, supported by the common council, drove a hard bargain with General Motors and the city of Detroit

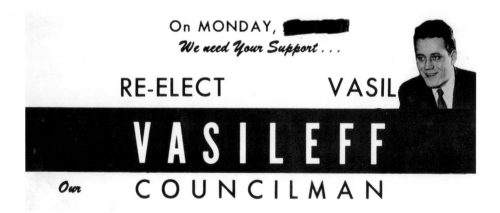

Vasil Vasileff was one of many bar owners who also held political office.

Robert Kozaren was by far the most successful politician/bar owner. Before serving as mayor for a record eighteen years, Kozaren operated Kozaren's Bar on Jos. Campau Avenue for a short while. He did much better as mayor.

(the proposed plant site spanned the border of Hamtramck and Detroit) which allowed Hamtramck to recapture the tax revenue lost from Dodge Main.

Kozaren also played a key role in founding the popular city Labor Day festival, which he did as a way to collectively boost the city's spirits after the closing of Dodge Main. He was incredibly adept at bringing national figures, like U.S. House Speaker Thomas "Tip" O'Neill, presidential wannabe Michael Dukakis and popular singer Bobby Vinton to Hamtramck for visits. Yet while he mingled with some of the country's leading political figures and entertainers, he wasn't above climbing on a garbage truck and hauling trash cans when the city got into a labor dispute with the Department of Public Works.

He had a knack for working with everyone, an ability he may have nurtured during the time he ran Kozaren's Bar on Jos. Campau Avenue in the late 1960s.

"His dream was to open a bar," said his daughter, Mary. Bob Kozaren got to fulfill that dream in an extraordinary way. Kozaren didn't drive a car and he didn't have a driver's license, but he did buy a raffle ticket at a fair sponsored by Orchard Lake, St. Mary's, a long-established Catholic prep school in a suburb northwest of Detroit. The grand prize was a brand new Cadillac. Kozaren won it.

"He kept it for a while, then sold it and bought the bar," daughter Mary said. But he soon found out one of the great challenges of owning a bar was the people who frequented

it. They were friends. They were supporters. They also liked to buy drinks on credit or expected drinks for free from their pal Bob.

So while that might have been good for building up a base of potential supporters, it was lousy for business, and the bar didn't last long. There was one lasting benefit, however: He met his future wife at the bar.

Kozaren came from a family associated with the liquor industry. His father, John Kozaren, had been appointed to the Michigan Liquor Control Commission and he was employed by Schenley Distilleries as director of Trade Relations for the Midwest. He also served as president of the Michigan Liquor Vendors Association and was Wayne County treasurer for a while.

John Kozaren wasn't the only political figure with connections to liquor outside the barroom doors. John Klinger, who was village president from 1916 to 1918, also owned a bar on Leuschner Street. Henry Kozak founded Kozak Distributors, a highly successful beer and wine wholesale business. That didn't prevent him from serving on the common council from 1950 to 1957 and running a spirited campaign against incumbent popular Mayor Al Zak in 1958. He also held various other posts including being on the Detroit Board of Water Commissioners and the Wayne County Civil Service Commission.

Tom Jankowski served a term as mayor, but said he didn't need to use his ownership of the Whiskey in the Jar Bar to achieve political success.

But owning a bar or having connections to the liquor culture was not an automatic ticket to political success, and not everyone in a position to benefit from it tried to. Tom Jankowski was mayor of Hamtramck from 2004 to 2006, while he owned Whiskey in the Jar on Yemans Street just off of Jos. Campau Avenue.

Political figures can draw their strengths from a lot of areas, he said, including being a member of social organizations, like the Knights of Columbus, the local Moose Lodge and so on. For him the bar was just that. "It's the quintessential neighborhood bar," he said. Small and inviting, like all the successful neighborhood bars, it nurtures a welcoming feeling, which is something he strives to achieve. The formula includes a wide variety of products, good prices and a great staff who make the bar feel like a place you want to be. In that sense, the essence of a bar hasn't changed in centuries. You can call it a beer garden, bar or saloon; as Jankowski said, it still can be a comfortable corner of the neighborhood without being a political launching pad.

On the other hand, Leo Rau's House of Rau was anything but subtle. This establishment featured hundreds of various objects hanging from the ceiling—guns, buckets, whatever—while Rau stood behind the bar, sporting a mustache, goatee and top hat. A post card advertising the bar sports the welcome "Hi! Sucker" in large letters. Rau shed the facial hair but still lost his bid for a seat on the common council.

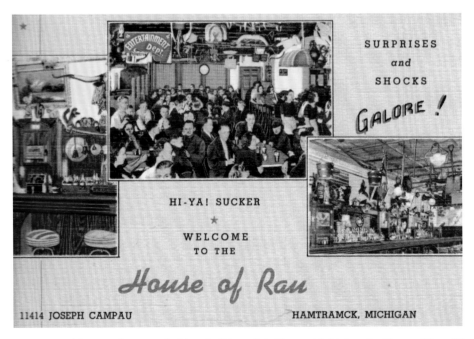

Leo Rau tried but somehow wasn't able to build a political base with his bar, the House of Rau. Of course, referring to his customers as "suckers" may not have helped his efforts.

City Clerk Al Zak shows the then-new business license form to Common Councilman John Wojtylo (standing) in July 1942. Wojtylo had an interest in business licenses—particularly liquor licenses. Although he professed being against the city granting such licenses he quietly applied for one. He was refused. And did we mention he was a cousin of Pope John Paul II.

At least one councilman opposed the owners of bars from holding public office.

John Wojtylo, one the feistiest members of the common council—and a cousin of Pope John Paul II, for what that is worth—brought the matter up in 1945. He "lashed out sharply against beer garden interests of any kind, particularly when it involved any city official," it was reported in the *Hamtramck Citizen* newspaper.

Unfortunately for Wojtylo, it was soon learned that he himself had applied for a Class C liquor license needed to operate a bar. However, the police had withheld approval for the license because of a prior application for the same license.

"In an attempt to overcome police objection, Wojtylo appeared last week before the Civil Service Commission to urge the removal of Police Chief John J. Sikorski, who approves such licenses," the paper reported.

The Civil Service Commission did not agree. Wojtylo remained undaunted, however, and filed numerous lawsuits against the city and even *The Citizen*, for various causes over the years.

Producing politicians wasn't the only way the bars exercised political power in town. They also could, or at least try, to influence policy. That was fully evident in the fall of 1950 when representatives of the Royal Ark Association, an organization of 89 Class C

liquor license holders, approached the Common Council and asked that no new licenses be allowed for the growing number of clubs that were opening in town. Private clubs had been a part of Hamtramck since its village days. But they experienced growth spurts, particularly after World War I and II when veterans formed associations. The Polish Legion of American Veterans was created just after World War I. The Veterans of Foreign Wars, AMVETS, Disabled American Veterans, Polish American Veterans Association along with the Knights of Columbus and other organizations all followed. But whether they were veteran oriented or ethnically inspired they shared a common factor—all served liquor. And they had a dubious advantage. They, unlike the bars, were open on Sundays because they were private clubs. And although it was illegal to serve liquor on Sunday even in a private club, that was a rule that often was broken. Further, the bar owners contended that the clubs welcomed non-members as guests of the members. All this amounted to unfair competition, the bar owners claimed.

In September 1950, Joseph Opka, president of the Royal Ark Association, appeared before the common council to ask that no more Class C licenses be issued in the city. "No organizations, no veterans, no nothing," he said. What brought the issue to a head was an application by the Polish Sea League to get a Class C license so that liquor could be served by the glass. (This Polish Sea League predates the current Polish Sea League in operation on Edwin Street.)

Local bars had frequent collisions with the Liquor Control Commission from the time Prohibition was repealed to the present. Usually it was for selling after hours or selling to a minor. Bel-Con Lounge got into trouble in 1960 for selling to a girl under age eighteen.

Mrs. Victoria Polec, president of the Polish Sea League, appealed to the council for approval of the license, saying that the club had spent $13,900 adding a bar and had planned to pay that off from sales of liquor. The Sea League was a social organization dedicated to preserving and promoting Polish culture and history. The license was approved by the council, but that didn't stop Opka from challenging it vigorously, saying the Polish Sea League was "not a bone fide club, but just a sham to obtain a liquor license."

At that time, Hamtramck had issued 28 club licenses and 17 were pending. In addition, because so many bars had come and gone through the years and Hamtramck's population was gradually declining—it was at about 43,245 at this point—the distribution of liquor licenses had become a tangled mess. Technically, the city was allowed one liquor license for every 1,500 people. But by 1950, the ratio in Hamtramck was closer to one for every 400 people.

Opka had originally approached Mayor Stephen Skrzycki to see if he could do anything to rein in the clubs, but Skrzycki had a practical understanding of the political landscape and passed the issue on to the council "to solve the problem in the best way." He added, "I don't believe I'm in a position to make any recommendations. I do believe that private operation is more desirable than large clubs because the private owner will be more careful to operate properly and according to law. I'm not criticizing any of the present clubs who adhere to the law."

He had a point in that the council, not the mayor, had control over issuing liquor licenses, but it was clear this was a political hand grenade he did not want to handle. But neither did the council. It was a no-win situation for the elected leaders. Oppose the bars and they would incur the wrath of the bar owners and their patrons. Side against the clubs and the veterans and other club members would turn against them.

Recognizing their dilemma, Opka told the council members that he knew they found the issue "too hot to handle," but that they shouldn't avoid it.

Of course they did just that. First, they put off making a decision until after they could attend a Royal Ark Association meeting. Then in October 1950, they really kicked the ball into the sidelines, stating that they would henceforth "not pass on the issuance or transfer of liquor or beer licenses of any kind," as reported in *The Citizen* newspaper.

"The decision to place such authority squarely in the hands of the police department was voted Tuesday night 2 to 1 with Councilman John E. Wojtylo offering the only opposition." Wojtylo was a colorful character that usually took an alternative view on any issue that was discussed. In fact, earlier he had refused to vote on any liquor licenses, but at this point he said the council should have the authority to approve or deny a license.

Councilwoman Julia Rooks proposed the resolution to turn the decision making over to the police, saying that the department did all the ground work investigating the approval requests anyway.

From there the issue got dumped into the hands of the Michigan Liquor Control Commission, which, in turn, dropped it back into the lap of the common council. The

LCC said it couldn't issue a license without the approval of the council. As this battle raged in the local press, it drew the attention of the big Detroit newspapers, which had often feasted on Hamtramck's colorful and copy-generating antics involving alcohol since the Prohibition days. The city was frequently in the spotlight for its corruption and well-deserved reputation as a "wide-open city." Things had calmed down considerably since Mayor Skrzycki was elected in 1942 and much of the corruption so rampant in the city had been stamped out. But try as it might—and it did try hard—the city could not distance itself too far from its past. A flashback occurred in late 1950 when Gov. G. Mennen Williams came to town. Guided by Liquor Commissioner John Kozaren, of Hamtramck, the governor apparently visited some bars and clubs on his trip. This was reported as a "Drunken Sunday afternoon brawl with state Liquor Control Chairman John J. Kozaren winking at Sunday liquor violations."

The story prompted Hamtramck Councilman Martin Dulapa to declare, "not one jigger of liquor was served in our presence," during the governor's visit and he proposed that the council pass a resolution condemning the newspaper.

Although the state denied it, Hamtramck suddenly became the target of a number of investigations into liquor law infractions. "We're not singling out Hamtramck," said

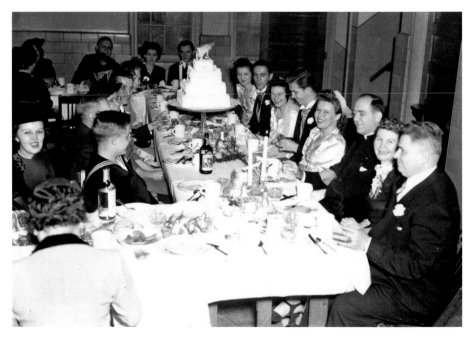

Irene and Alex Smolenski celebrate their wedding at the Polish Legion of American Veterans Post No. 1 hall on Holbrook Street in November 1943. Private clubs like the PLAV drew the ire of bar owners because they could get liquor licenses too, and hold special events there.

George J. Burke, Jr., chairman of the Liquor Control Commission, as he singled out three Hamtramck clubs that were cited for selling booze on a Sunday in February 1951. Hit were the Polish Army Veterans Association of America on Holbrook Street, the Kosciuszko Democratic Club on Caniff Street and the Hamtramck Home Owners Association head-quarters, also on Caniff Street.

The following June the Liquor Control Commission handed down its judgment, and it was hard-hitting. The Kosciuszko Club and Home Owners each drew a 60-day suspension. The Polish Army Veterans drew a 30-day suspension and a $200 fine. In announcing the penalties, Liquor Commission Examiner Kenneth J. Daniels said the Kosciuszko Club deserved "having the book thrown at them" because manager Mrs. Stanley Bienkowski reluctantly admitted the investigators when they arrived at the place on a Sunday and then swept the bar of "all liquor using her handbag." The Polish Veterans got off a tad lighter because they appeared to be friendlier, welcoming the state officers into the club. Typically such infractions drew 15- or 30-day suspensions and sometimes a fine.

More raids would follow, but for a while it was made to appear that "Hamtramck is still Hamtramck," as the *Detroit Free Press* put it.

Really, it wasn't. Hamtramck's wild days were over. It took a while for the fires to burn themselves out and there would be occasional flare ups, as when the state took over the Public School system in 1946 following a scandal in which several school board members were implicated in a scheme to "sell" jobs—You want to be a teacher? Give me 500 bucks and I'll get you a teaching job. But even that paled in contrast to the Prohibition days when buying city leaders, including police officers and officials, was a way of life.

Bars, clubs and liquor stores would continue to break the rules from time to time, right up to the present, but the fiery days of the past were over. At last.

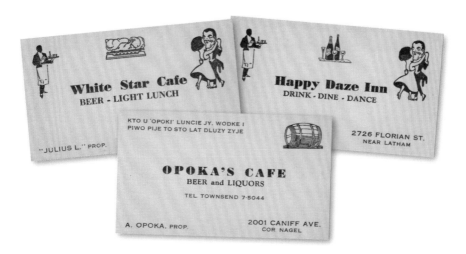

3

PROHIBITION, HA!

"I don't understand," said Our Friend, the Drinker. "All my life I have beer. Now they tell me, 'No! You cannot have beer.' This is crazy."

He tenderly put the bottle of beer on the counter, almost as if he were saying goodbye to an old friend. He wasn't alone in feeling that way. Millions of other Americans shared his pain. Some may have understood it better, but it didn't really matter. What was happening was stunning to them. But perhaps no one felt worse than the bartender who knew that soon he would be out of a job, or maybe working in a bar behind closed doors. But who ever heard of such a thing? A bar with closed doors where you had to knock to get in and only if the person on the other side of the door knew you.

He too thought, "This is crazy."

But the doors were about to swing shut for bars across Michigan as the start of Prohibition was soon to begin. It didn't happen all at once as different states and even counties adopted Prohibition over the course of several years. In Michigan a Prohibition law was passed on May 1, 1918, but that was challenged in court and overturned. A second Prohibition act was passed by the Legislature in March 1919. That, too, might have been challenged in court but before it could be brought up, the U.S. government approved a Constitutional amendment making Prohibition the law of the whole country.

Everywhere bars were shuttered or turned into something else. Breweries were forced out of business or switched to a handful of options available to them. For example, they could continue making beer, or rather "near beer," which initially had an alcohol content of 2.5 percent. That was later dropped to 0.5 percent, which is essentially colored water. Other breweries switched to producing malt extract, which was promoted as a product to be used in baking, although home brewers found a more potent use for it. Still others got even more creative, turning their facilities to producing dyes or ceramics; after all, they already had vats and ovens.

The question of what to do weighed heavily on Joseph Chronowski's mind as Prohibition

A cigarette and sultry look characterize this postcard photo produced by Wojnicki Bros. photo studio. [*Christopher Betleja collection*]

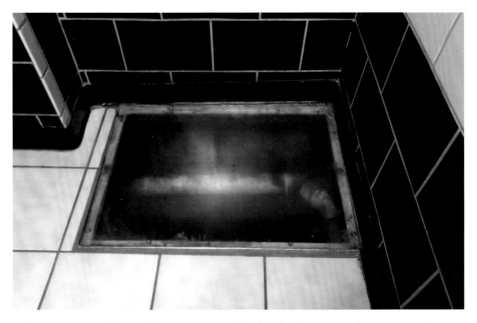

A lingering vestige of the Prohibition era can still be found in the New Dodge Bar on Jos. Campau Avenue. The old Prohibition tunnel that once connected the bar to a nearby building can still be seen in the bathroom of the bar. The tunnel was used to haul liquor unseen.

approached. Chronowski owned Auto City Brewery, one of the most successful breweries in Hamtramck. Like most brewers he must have struggled with the concept that his viable business that employed many people and contributed to the economy of the city was about to go bust through no fault of him or his employees. And certainly not his customers. Although Chronowski was a well-educated successful businessman he shared the same thoughts as Our Friend, the Drinker, who was a common immigrant laborer.

This is crazy.

But while Our Friend, the Drinker could do no more than longingly stare at the beer bottle before him, Chronowski had an option. As Auto City's doors closed he opened new ones in the form of Liberty State Bank in 1918. Conveniently located on Jos. Campau Avenue at Norwalk Street in an impressive brick building with leaded windows and carved stone trim, it was a success from the start. This beer brewer apparently knew a fair amount about banking, for Liberty State Bank was one of the few banks in Hamtramck to survive the devastation caused by the Great Depression. In 1936, the bank moved to bigger, even more impressive quarters at the corner of Jos. Campau Avenue and Holbrook Street. It remained there for many years and ultimately was bought by the Huntington Bank, and still operated as of 2017.

Auto City Brewery seemed to have a prosperous future ahead when Prohibition was instituted and caused it to close—at least legally. It did reopen after Prohibition ended but didn't last long.

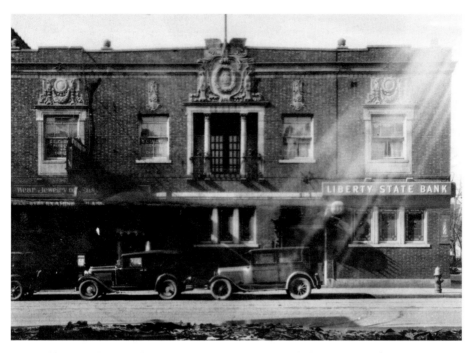

Joseph Chronowski owned Auto City Brewery but had to find a new line of work because of Prohibition. He did: banking. Liberty State Bank not only survived the Great Depression but thrived. It remains in business today as a Huntington Bank branch.

As for Auto City, Chronowski turned it over to his brother, who tried to produce legal substances there before another relative took over and went back to brewing beer. That is, until he was nailed by the Feds and sent to Leavenworth prison. Auto City legally reopened after Prohibition ended in 1933, but only lasted a few years before going out of business. Joseph Chronowski remained a successful businessman throughout his life. He found an opportunity despite the hardship imposed by Prohibition. So did a lot of other Hamtramckans, including leading city figures, but not at the level of respectability of Chronowski. In fact, for many Prohibition was an opportunity, one in which they generously indulged, although they didn't want that fact known.

Almost as soon as the bar doors were officially closed across town, they reopened. Within a few years Hamtramck was known as a wild town where drinks were served freely in hundreds of speakeasies that sprang up. There even is an account of a bar operating freely a short distance from the police station. Perhaps "freely" is a poor choice of words. There was nothing free about what went on there. The patrons paid and the owners had to cover the cut the police demanded to stay out of the way. And the cops were pretty good at somehow managing not to see the incredible amount of liquor that was flowing through

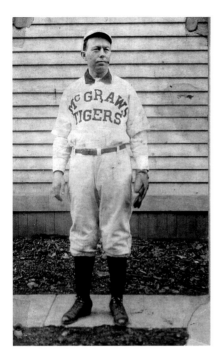

Patrick "Paddy" McGraw ran one of the most successful brothels/speakeasies in Hamtramck. He also was a well-respected citizen of Hamtramck and was involved in many community activities, including sponsoring a baseball team.

Hamtramck. But the Feds had keener eyesight. Within a short while newspapers across the country, but especially in Detroit, were printing stories on the conditions in Hamtramck. Its reputation was set as a town where you could get a drink anytime, anywhere. That was bad publicity but great advertising in an underhanded way for the city. Thirsty Detroiters, including city officials, quickly learned that Hamtramck was neutral territory. They could come to town for a quiet drink and no one would bother them. Even the notorious Purple Gang, perhaps the most brutal gang of the period, carried out its operations in Detroit but supposedly came to Hamtramck to drink in peace.

It isn't possible today to actually name bars of this period, if they even had real names. We do know that the brothel/speakeasy operated by Patrick "Paddy" McGraw was well known, but simply as "Paddy McGraw's." Paddy McGraw is worth a chapter to himself. One of Hamtramck's preeminent citizens, McGraw co-founded the Hamtramck Goodfellows, which raised money to buy toys for needy kids at Christmas. He also sponsored local sports teams and had a zoo made up of stray animals he took in. His place stood like a beacon on Clay Street at the south side of town. Paddy ran his business through Prohibition, but ironically could not compete with the bars and brothels that opened after Prohibition, so he closed up shop in 1936. He was so well liked by the locals that in 1946, on the tenth anniversary of his death, *The Hamtramck Citizen* newspaper wrote a touching front-page memorial.

Chester LeMare was a far less liked character, but no doubt the liquor was poured at

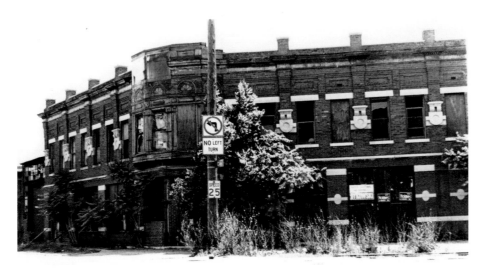

Paddy McGraw's place in its final days just before it was demolished in September 1981. The building, by the railroad tracks at Clay Street, was torn down to make room for the General Motors Detroit-Hamtramck Assembly Plant.

the Venice Café, his spaghetti restaurant on Jos. Campau Avenue. LeMare was known as "Hamtramck's vice king," and was little more than a vicious murderer. He was shot by rival gangsters in Detroit.

One of his regulars at the Venice Café was none other than Peter Jezewski, Hamtramck's first mayor.

By the late teen years of the 20th century, the animosity between the Germans and Poles reached the boiling point. Stymied at almost every attempt to increase Polish political power in town, the Poles were drawn to act when rumor spread that the German politicians were trying to work out a deal with Detroit so that it could annex Hamtramck yet leave the Germans in control. This may not have even been true, but it was accepted as fact and ignited the Poles who drafted a petition for the village of Hamtramck to become the city of Hamtramck. Cities cannot annex other cities so that move would have protected it from being swallowed by Detroit. The effort was successful, and in 1922 Hamtramck officially became a city. Nearly all the German politicians were tossed out of office as the new city common council was elected. Jezewski, a pharmacist originally from New York, was tapped as the first mayor. This was in the depths of Prohibition when money was plentiful and politicians had price tags just dangling from them.

In 1923 the Michigan State Police came down hard on the new city, taking over police activities and raiding all the illegal operations they could find, including individual residences. Over a three-month period more than 75 places were raided. The result was

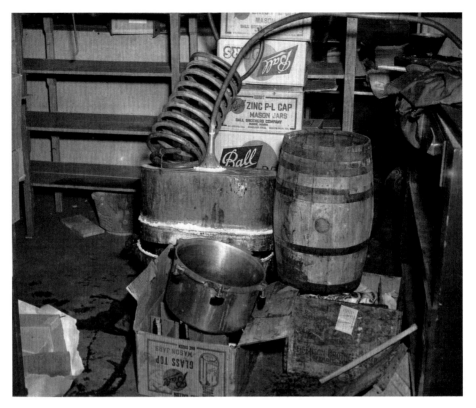

All the makings for a Prohibition still are right here. Police uncovered hundreds of illegal stills even long after Prohibition ended.

virtually nothing. Home stills were put back into action and the big speakeasies were so well connected with the local police they were tipped off before they were raided. Eventually, Jezewski was arrested and sent to prison for his involvement in corruption, as was one of his successors, Mayor Rudolph Tenerowicz, several years later. The impact of such a scandal on their careers was nonexistent. Tenerowicz, a popular physician, was so well liked that while he was jailed thousands of Hamtramckans signed a petition that was sent to the governor demanding his release. The governor, a Democrat, noted that Hamtramck routinely had voting turnouts at elections of nearly 90 percent and almost all of them were Democrats, acceded to their wishes.

Tenerowicz was released from prison and escorted home to Hamtramck where a big party was held welcoming him. And his pals gave him a brand new car.

You could almost hear the state and federal lawmen groan with frustration.

But look what they were up against. Virtually everyone in Hamtramck (like the rest of the nation) hated Prohibition. It was against the culture and history. There were understandable

OFFICE OF THE DIRECTOR OF PUBLIC SAFETY

City of Hamtramck
Wayne County, Michigan

Joseph L. Wisniewski
DIRECTOR OF PUBLIC SAFETY

STATEMENT

"It is deplorable to say the least that the ungrounded and false insinuations of graft in the City of Hamtramck should be published in the newspapers of Detroit. Since I have been Director of Public Safety in Hamtramck, the City has been absolutely free of graft and corruption. I am particularly proud of the Hamtramck Police Department. It's record in law enforcement surpasses that of any other City in Michigan.

It is indeed unfortunate and I think the people of Hamtramck resent the fact that elected officials resort to personal vilification in the Detroit press to gratify their political ego in an attempt to continue their petty political feuds to the detriment of the good name of the City of Hamtramck.

I personally welcome any investigation of the Hamtramck Police Department, fully confident that the findings will substantiate these facts."

Jos. L. Wisniewski

Hamtramck developed such a sordid reputation during Prohibition for the rampant corruption in town that it took decades to shake the image. In 1941 Joseph Wisniewski was appointed public safety director and found himself confronted by a hostile Detroit press and feuding local politicians charging each other with corruption.

and justifiable reasons to support Prohibition. A bar could be a place to relax and have a lot of fun. But they also could be family destroyers, places were husbands squandered meager paychecks while the wife and kids scrambled to pay the rent, the electric bill, and buy groceries. It wasn't rare to see a wife or even child go from bar to bar to track down an errant husband or father. Alcohol can be a devastating drug.

Even so, most people who frequented bars did not destroy their lives, and many had been drinking long before they even came to America. So there would be periodic raids that would lead to nothing.

But some things would strain the limits of what was excusable. In March 1929, police officer Thomas Gadwallader was brought up on department charges for "entering a place where intoxicating liquor or drinks are sold or kept, excepting in the immediate discharge of police duty." Specifically, "Officer Gadwallader was found loitering in a blind pig at 11339 Dequindre at or about 7:15 p.m. on March 8, previously having ordered a glass of whiskey to be served to him."

A hearing was held but he was found not guilty. That wasn't the end, however, as officer Gadwallader continued to have problems with alcohol and was found guilty in another

hearing. He wasn't alone. At about the same time, a Hamtramck firefighter was charged with drinking on duty. But after a hearing he was found not guilty.

And it shouldn't be interpreted that the Hamtramck police did nothing to battle the bottle. Raids were conducted and monthly reports were made to the common council. In March 1929, two stills were confiscated along with 61 gallons of whiskey, one pint of gin, four half-barrels of beer and 24 pints of beer. In addition, 41 barrels of mash were destroyed. During the month, nine liquor raids were conducted: six in private homes, one in a confectionery, one in a pool hall and one on a transporting operation.

In July 1929, 20 raids were conducted, including twelve in private homes, two in candy stores, two in near-beer parlors and two in pool rooms. In addition, seven stills were confiscated along with 215 gallons of whiskey, a pint of gin, a quart of wine, seventeen barrels of beer and seventeen half-beer kegs.

In fact, the police were so involved that Assistant City Attorney Seneca C. Traver told the common council in 1924 that performing the necessary lab tests on the confiscated liquor required for prosecution was busting the budget. Traver recommended that further confiscated samples be sent to the county liquor control department for testing and to let them pay for it because if the city continued to do that "this allowance of account will wipe our total budget for witness fees, etc., for the whole present year," Traver sternly warned. There's no record if the council followed that advice.

One way or another Prohibition kept the police pretty busy.

Nevertheless, police duties decreased at least somewhat on Dec. 5, 1933, when Prohibition was officially repealed. Beer was back—not that it ever had really gone.

In took several months for bars and breweries to reopen. But soon Auto City brewery was in business again and Hamtramck's other brewery, C&K, also began brewing beer again. And the bars opened. Over the next few years Hamtramck's bar scene began to reassemble. Al Ziskie's Bar on Jos. Campau reopened. White Star Tavern opened right next the White Star theater on Jos. Campau Avenue (not to be confused with the White Star Bar that opened on Conant Street years later). Paul's Bar on Caniff Street already began promoting dancing. And Half Moon Café, on Jos. Campau Avenue, began serving beer and light lunches. Around 1935, The Bowery, what would become Hamtramck's legendary night club, opened. And in 1936 Senate Café, Spanish Café and Nite Owl Inn among others opened their doors.

How many were there? That's hard to say. Local lore says that Hamtramck, within its 2.1-square-mile area, once housed anywhere from 200 to 400 bars. And that Hamtramck had more bars per capita than any city in America.

That seems rather high considering Hamtramck's population, which was substantial in the early 1930s at about 56,000 people, but not high enough to warrant 400 licenses for bars. Detroit, a far larger city than Hamtramck, with a 1930 population of about 1.5 million, had a quota of 500 licenses. But there may be some confusion over the distinction among bars, restaurants and liquor stores like Pop's Retail Beer Store on Leuschner Street,

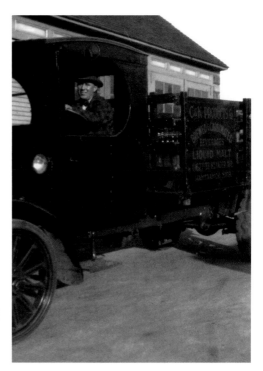

With the end of Prohibition in 1933, the bars and breweries were back in business. Along with Auto City, C&K brewery found success when the dry ages ended. The C&K building still stands although the brewery went of business years ago.

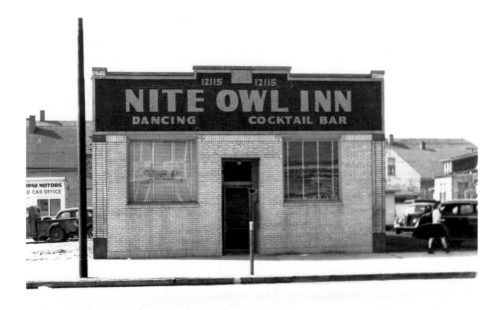

Nite Owl Inn was one of the bars that began serving not long after Prohibition ended and the bar scene reassembled.

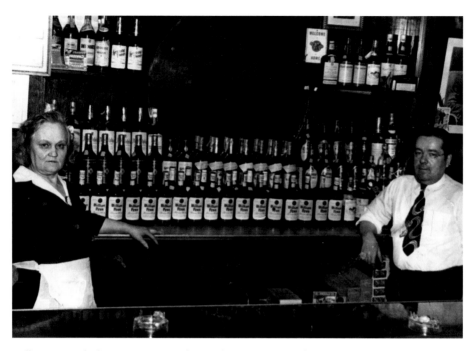

William Penn whiskey was pretty popular at White Star Tavern when bars returned after Prohibition.

and Wholesale Beer Distributors on Caniff Street. Considering all of them, the number was about 200. We know that because in February 1936, police Chief Joseph Rustoni asked for all license holders to apply early for license renewals. The licenses were due to expire on April 30, and Rustoni said the process for filling out the renewal applications was so complicated that it could delay approvals. "It is necessary to photograph and fingerprint the applicants, besides attending to a great many clerical details," he said.

So how many were bars?

We can get an indication from the fact that Hamtramck was entitled to 54 licenses for places that sold liquor by the glass in 1934. But, in fact, State Liquor Control Commissioner Frank Picard approved only eighteen of them that first year.

"It will ensure better living conditions," he said.

Maybe, maybe not, but it soon became clear that not even the city knew just how many bars and other places sold liquor in town. In 1936 the common council came to realize the city had more liquor licenses than it was allowed to legally have. It happened when Bill Warner, who represented the Class C license holders (clubs, bars), appealed to the council to not allow any more licenses in town. He said there were so many already they had diluted the drinking population to the point that the bars were finding it hard to make a profit with so much competition. That prompted the council to investigate just how many

licenses there were out there. They discovered that the state allowed one license for every 750 residents, and using that formula Hamtramck was entitled to 68 licenses at the time. But as of March 1936, there were 91 Class C licenses in town. By not keeping tab of the applicants, and in the confusing mess that transfers can create, the number had grown substantially. The council determined it wouldn't be fair to revoke any of the licenses that had already been issued, especially since many of the bar owners made significant investments in their property, so it decided to just not approve any new licenses.

Even so, it doesn't appear that an accurate number of establishments selling liquor was ever determined when taking into account bars, clubs and stores. Even the state got into the act. In 1934, the state opened a liquor store in the city. It soared in popularity and became one of the top selling liquor stores in the state (what a surprise!), and it gave an insight into what the most popular drinks were.

"In Hamtramck, the older people prefer the hardest liquor," Joseph Wisniewski, manager of the store, said in July, 1935. "Judging from the stock turnover, smaller bottles of gin are the fastest sellers and wine is the slowest." They would have known. The store carried 65 varieties of gin, "domestic and imported" along with 100 different brands of rye whiskey and 80 varieties of bourbon including 36 bottled before the Great War (World War I). Add to that were 35 varieties of Scotch and even French cognac selling from $3.50 to $9.55 per bottle, which in 1935 prices was pretty hefty. Additionally, the store sold mixed drinks including Manhattans, martinis, Bronx side cars and old fashioneds. Even the bottles were popular. Some were so ornate that they often were made into lamps.

Locating a liquor store in Hamtramck was one of the most successful decisions the state would make, liquor-wise. Others actions were more questionable.

For instance, in 1935 the state passed a law regulating the size of curtains and partitions used by bars and restaurants selling alcohol. The law specified that window curtains could stretch up no more than 42 inches from the floor. Enclosed booths with partitions higher than 42 inches were also outlawed. Why? The answer is surely buried in some obscure compilation of laws. In any case the state left it up to the city to enforce the law. That same year the common council considered a more weighty issue—a proposal to change the closing hour of bars from 2 a.m. to midnight. But the measure was unanimously shot down by the council.

"To force the legitimate, licensed beer gardens to close at midnight would only drive people to blind pigs, and this gives those legitimate enterprises trade which would be wrested away from our law-abiding tradesmen," said Councilman Joseph Mitchell.

The council took up the matter at the request of the city of Lansing, Michigan, which adopted a midnight closing time, and Lansing officials were anxious to get support for the change from other communities. The Hamtramck council's refusal was telling in that there was an official recognition that blind pigs still operated in the city. A lot of the city's corruption was swept away with the end of Prohibition, but illegal stills, gambling and prostitution would remain active until the 1970s.

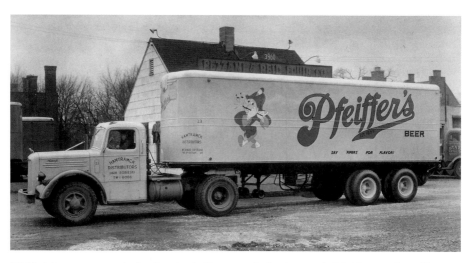

Pfeiffer's beer was a particular favorite in Hamtramck. It, along with E&B beer and Stroh's, were perennial favorites.

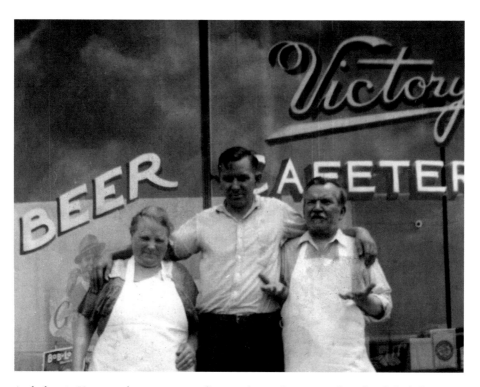

As the bars in Hamtramck grew to astounding numbers, other venues also offered alcohol. Victory Cafeteria on St. Aubin Street sold beer too. At the cafeteria in 1938 are Mary and Stan Wisniewski with son Charles (center).

In 1938 the city looked at enacting another first, this time just the opposite of the early closing. To ring in the New Year of 1939, the city allowed bars to stay open all night and serve beer and light wine on New Year's Eve, although they could not serve liquor after 2 a.m., as required by state law.

Hamtramckans needed the extra celebration time. The city was still in the Great Depression, although economic conditions had improved. The threat of war was growing, which had a special impact on Hamtramck where a large proportion of the population had close relatives in Poland, next door to Germany.

Within a year Europe would be at war and in December, 1941, the United States joined the fray. For the bars there was the expected decline in patrons as a growing number of young men were drafted. As the war went on bars began displaying photos, flags and other war memorabilia from patrons in the service. Parties honoring servicemen and servicewomen on leave were held at bars even as a more muted tone descended over the entire city. Everyone knew what was at stake and the reality that life was changing sank in quickly. Husbands, fathers and sons departed to the war zones leaving fractured families. Rationing was imposed on many everyday goods. New cars became unattainable as auto manufacturers switched to producing war materiel. Then the dreaded telegrams stared arriving. One, then a few, then a steady flow. The casualty lists printed in *The Citizen* newspaper gradually grew larger each week. Even kids were affected as they began to stage often monumental paper, metal and rubber drives to collect things that could be recycled for the military.

Everyone was involved. But the bars still filled their traditional role as outposts of escape from the world outside their doors.

A young lady and a soldier either on leave or just returning from the service enjoy a visit to a typical World War II-era bar in Hamtramck.

4

IN THE SWING

Our Friend, the Drinker looked in the mirror. He slicked back his hair, then put on his army cap, tipping it at just the right angle. He was more than a little pleased at what looked back at him. He was ready. He had just gotten out of the army after World War II and he was in the mood for some company of the female persuasion.

But where to go? There were plenty of places to choose from like the Air Port Bar on Jos. Campau Avenue, or the Blue Goose Inn on Lehman Street. They're pretty good, but this night was going to be something special, and only one place would qualify for that.

The Bowery.

From the mid-1930s to the early 1950s Frank Barbaro's Bowery Nite Club brought in some of the leading entertainers in the nation to perform in Hamtramck. It billed itself as "Hamtramck's only nite club," and technically was, if you define that as an establishment that primarily offered evening entertainment, along with food, drinks and dancing with the accent on entertainment. And it was entertaining. The list of headliners is impressive: Martha Raye, Ella Fitzgerald, Tony Martin, Henny Youngman, Jimmy Durante, Gypsy Rose Lee, Joe E. Lewis, Sally Rand, the Harmonicats, John Boles, Milton Berle, The Three Stooges and Sophie Tucker among many, many others. A lot of these names may not be familiar to today's generation, but in their day they were A-List stars. And anyone today who doesn't know who Ella Fitzgerald is has no business thinking they know anything about music. Are those fighting words? You bet. It's a good thing The Bowery hosted amateur boxing matches, too.

Patrons would show their appreciation for an act or order drinks by tapping wooden knockers placed on their tables for that use. And a roving photographer could snap your picture and have it for you to purchase in a handsome Bowery Nite Club folder.

The Bowery was a lively place and its reputation grew as it attracted bigger name stars. Frank Sinatra stopped by. So did Harpo Marx. Vintage photos show Jimmy Durante, Eleanor Powell and many others at The Bowery. As its reputation increased, The Bowery

The Bowery Nite Club became one of the leading night spots in the Midwest. Major acts like Sophie Tucker, Danny Thomas and The Three stooges, among many others, performed there.

Singer Sophie Tucker chats with Bowery owner Frank Barbaro (left), and labor leaders Walter Reuther (right) and John Frankensteen at the club.

Above left: A dapper Frank Barbaro operated The Bowery from the 1930s until he and his wife divorced in the late 1940s. She got the club in the divorce settlement and it closed in the early 1950s

Above right: Bowery patrons had the option of having their photo taken and preserved in a personal album they could buy.

expanded its advertising slogan to note it was "known from coast to coast." It wasn't an exaggeration. It did well locally too, as leading metro Detroit figures also became regulars. Labor titans Walter Reuther and Richard Frankensteen came in. It was great for bragging rights, but still, the majority of the habitués were Hamtramckans coming just down the street to its snug spot in the middle of the block at 12050 Jos. Campau Avenue.

It appeared that things couldn't get much better at The Bowery all through the '40s, but the story behind the curtain was anything but harmonious. Frank ran The Bowery with his wife, Dorothy, but by 1947 their marriage had soured and they were divorced. As part of the divorce settlement, Dorothy got majority stock ownership of The Bowery, putting her in control. Things did not go well. In May 1950, The Bowery closed. It was reported The Bowery was losing $500 to $600 a week and had assets of $18,645 with liabilities of $70,634, and Dorothy filed for bankruptcy. By September, John DeGutis bought The Bowery and reopened it, announcing that Frank Barbaro would serve as director of entertainment. It isn't clear what happened, but apparently The Bowery was not reborn, at least not in Hamtramck.

But in 1956 Frank Barbaro opened The New Bowery Supper Club on Cass Avenue in Detroit. It promised "Dinner—Dancing—Huge Show." But that's about all there was.

Nothing seemed to come of that plan. The Bowery building in Hamtramck was bought by Woodrow Woody, who owned the big Pontiac dealership, and the site of The Bowery eventually became a parking lot. But it's not completely gone. The imprint of the roof line is still visible on the building just south of the lot.

Frank Barbaro was known to have a body guard, which raises another aspect of bars that is far darker. It's the recipe of money, alcohol and guns, which can mix into a deadly brew. Bar robberies have probably occurred since there have been bars. Usually they make the evening news—if someone is killed—then are forgotten by the general public in a day or two. But there were exceptions, such as the murder of bar owner Peter Kubert in May 1942. Kubert was proprietor of Pete's Kubert's Bar on Carpenter Street, an especially popular place. Kubert appeared to be one of those guys who was everywhere in town, friends with everyone and well liked by all, which is one reason why his death hit the whole community so hard. Another reason is that he was killed by Hamtramck's most notorious criminal ever, Roman Usiondek.

Usiondek capped off a busy Friday night with his gang by strolling into Kubert's place, pulling guns, herding seventeen customers into a back room and raiding the cash register.

At that point they had already robbed Emil Miles' Bar on St. Aubin Street of $100 and Sonny's Café on Van Dyke Road in Detroit, where they got $1,100. That success may have empowered them to hit again, and so they came to Kubert's place at about 1:12 a.m. Disappointed at the meager $400 they found in the cash register, they demanded more from Kubert. According to the account in *The Citizen* newspaper, "Kubert pointed to some

Shananigan's on Carpenter Street was Pete Kubert's bar in 1942. And it was there that he was murdered. It was a crime that shocked the community as few others had.

nickels and dimes sarcastically and one of the bandits fired. Kubert thereupon leaped for his gun behind the bar and fired five shots, all of which apparently went wild."

The robbers fled. Kubert was taken to St. Francis Hospital in Hamtramck where he was operated on successfully, but died a week later from peritonitis. The city was shocked and outraged. The common council unanimously approved the offering a $500 reward for information leading to the capture of Kubert's killers. An intensive police investigation led to the capture of five men, one of whom was later acquitted.

Usiondek drew a life sentence, later escaped from prison, was convicted of another crime and was released from prison in the late 1970s. He returned to Hamtramck and promptly committed another murder when he shot the owner of a local market one afternoon. Beset by police and finding himself cornered next to the St. Ladislaus Church convent parking lot on Caniff Street, he shot himself. And that is only a brief synopsis of his incredible career of crime that dated to the 1920s.

Other shootings, robberies and murders of varying degrees of intensity have occurred in Hamtramck bars over the years. As recently as 2014, Club Aces on Jos. Campau Avenue drew fire from the city, which threatened to pull its license after three persons were shot. Fortunately none died. The club has since closed.

But it's time to go back to The Bowery, where the murder of Kubert surely must have weighed heavily on everyone there.

The Bowery reigned as Hamtramck's most sophisticated night spot and one of the finest night clubs in the Midwest. But it wasn't the only night club around. Nearby in Detroit there were places like Club Alicia on Mt. Elliott Street, Club Steveadora on Harper Avenue, Mickey's Show Bar on Seven Mile Road and Club 509 on Woodward Avenue in Detroit. All focused on evening entertainment as their main drawing point, not drinks. And they hosted real entertainers, not like the bartender who played guitar at the House of Rau when it had its grand opening in 1944. We're talking about the professional singers, comedians and performers of whatever else one can present in a night club without getting arrested.

This was part of a subtle but growing shift in the character of drinking spots that locally followed a logical progression. They started as shot-and-a-beer dark temples dedicated to alcohol, then evolved in adult social clubs, then political centers of town that took a left turn into the wild world of speakeasies during Prohibition. After Prohibition they became more relaxed saloons and cocktail lounges where music and food began to play bigger roles in what was offered.

Many bars began to advertise themselves as "cafes" and promoted their kitchens over their liquor. Kosciuszko Café, at the corner of Jos. Campau Avenue and Caniff Street, was typical. It touted itself as the "finest, most modern café in Hamtramck." It offered "paczki for Lent." (And here we must pause to digress. *Paczki* are traditional Polish doughnuts, usually filled with jelly or something else sweet. Technically authentic *paczki* [pronounced *poonch-kee*] are only available just before Lent begins, because they were to be made with the rich ingredients

Kosciuszko Restaurant & Bar - 10233 Jos. Campau Ave., Hamtramck, Mich.
JOHN NOWICKI, Proprietor

Kosciuszko Restaurant and Bar followed the postwar trend of focusing on food instead of drinks. It later became known as the Washington Café and carried on that tradition.

like lard and sugar that good Polish Catholics gave up during Lent. So you indulged in a greasy, calorie-laden pastry in the name of God. Fortunately, the tradition continues today. And with that Our Friend, the Drinker, chomped down into a prune delight.)

Anyway, the Kosciuszko Café later became known as Washington Café and boasted it had the longest bar mirror in Hamtramck. It actually was a series of mirrors about twenty feet long installed, no doubt, so that you could watch yourself fade into an alcoholic haze.

The Balalika Bar, at 8809 Jos. Campau Avenue in the 1940s advertised that it served "frog legs, oysters, steaks."

Imperial Bar, at 8850 Jos. Campau, operated by Vincent Sadlowski, a Hamtramck politician, as noted earlier, promoted "Fish and Chips Fridays. Full course dinners Friday and Saturday."

Seven years after the horrific murder of Peter Kubert, his wife Sophie was operating Sophie Kubert's Bar in the same location. She offered "Fish Fry Fridays. Come in and enjoy it with us."

Over at Louie's Dodge Bar, at 9119 Jos. Campau Avenue, proprietor Louis Maiiat was "Serving one of the largest B-B-Q kielbasa sandwiches in town."

Tardie's Bar, at 2206 Caniff Street, might have taken exception to that. Proprietor Joseph Tardie advertised that is was "now serving daily kielbasa sandwiches, chili and hotdogs."

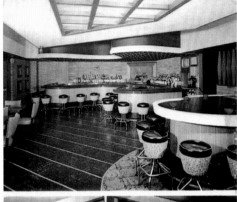

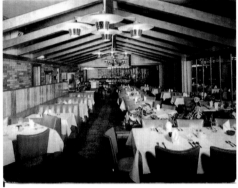

Gensey's Chop House on Jos. Campau Avenue was recognized as one of the classiest places in town in the 1950s. The food was also tops and cheap—lunch for $1.

White Front Café, at 8833 Jos. Campau Avenue, offered "Frog legs, chicken." But even more attractively, it was "the only air-conditioned bar in Hamtramck south of Holbrook." At least in 1953.

Gensey's was perhaps one of the classiest places of the 1950s. It has an "ultra modern, expensive-looking interior," according to *The Citizen* newspaper. But Gensey's owner, Ed Orlowski, knew Jos. Campau Avenue was not Park Avenue, so you could get a full lunch for less than a dollar.

Using food as a lure to reel in customers wasn't exclusive to the swing era. From the earliest days bars offered peanuts, boiled eggs and other thirst-inducing foods. As the menus grew more sophisticated some bars developed specialties. Midtown Bar was a landmark on Jos. Campau beginning in the 1940s. Midtown became synonymous with fish dinners, and for a long time it had a cross-town friendly rivalry with Old Mill Bar, which actually was in Detroit, but just across the street from the border. It also was known for its fish dinners.

"We sold as many as 700 dinners in a day," said John Stofanik, who ran Midtown Bar in the 1960s and '70s. "I had a beautiful bar," he said. He even set up a grill in the back and built a loyal base of customers including local businesspeople. Many became friends.

Midtown Bar on Jos. Campau Avenue took food to a higher level than most bars. It became known for its fabulous fish dinners prepared by (from left) Delores Terebus, Ann Bush and Genevieve, Debbie and Roselee Skorupa.

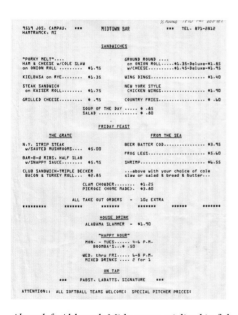

Above left: Although Midtown specialized in fish, it offered a full menu, shown here at 1970s prices.

Above right: The sign on the back of the building is faded, but the memories are still fresh for John Stofanik, who operated Midtown Bar for years.

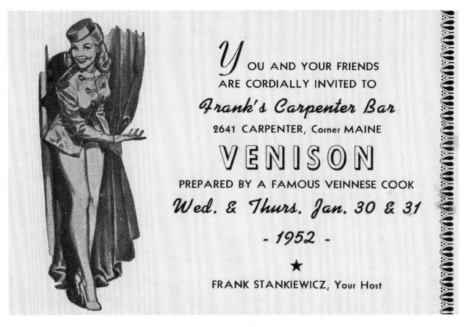

In 1952 Frank's Carpenter Bar offered something different with its venison dinners.

"We golfed together, we bowled together, we went on trips together. "It was better than a neighborhood bar."

It was, he said, "a fun place."

To enhance the fun, many bars began to use music to widen their appeal beyond just the drinkers. Playdium Bar at the already popular Playdium bowling alley presented "entertainment by one of Chicago's favorite night club orchestras."

At the Orchid Bar at Evaline and Charest streets, Joseph Burzynski performed on his accordion. Meanwhile Evelyn Wayne and her accordion could be heard on Fridays and Saturdays at the Esquire Show Bar.

Three Star Café, at 11902 Jos. Campau Avenue, offered dancing Friday and Saturday to the music of Frank Szalankiewicz. And when Vasil Vasileff opened his Jungle Show Bar in 1958 he held a jazz jamboree complete with a four-piece orchestra.

Richie's Bar on Evaline Street announced "Big News!" in November 1950. There would be "dancing nightly, seven nights a week plus Little Joe Shawl and His Trio."

Some bars, however, never got past the jukebox stage. That could be cheaper but presented challenges. In July 1948, the bars with jukeboxes found themselves embroiled in a war. Actually it was a dispute between two unions—the American Federation of Labor (AFL) and Congress of Industrial Organizations (CIO), which were separate at that time. The problem was that the AFL workers maintained the jukeboxes in some bars and

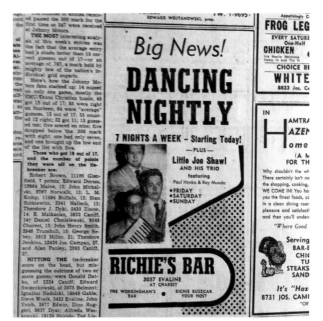

By the late 1940s, dancing began being added to the mix. Bars crammed dance floors in between the tables and brought in live bands. Richie's Band promised dancing seven nights a week in May 1950.

restaurants while the CIO workers took care of others. They apparently got into a turf war and took action by setting off stink bombs in the businesses served by their rival union.

The Homestead Tavern on Pulaski Street was hit with a stink bomb, and George Palmer, owner of the Gateway Restaurant on Jos. Campau Avenue told police he received a subtle threat that if he didn't remove the jukebox serviced by AFL workers "something would happen." Nothing did, but a series of establishments in Hamtramck and Detroit were hit in a short span of time.

But whatever prompted the rivalry was apparently settled internally as the smelly attacks suddenly stopped. That was good, especially since the trend at that time was for bars and clubs to highlight food, as well as entertainment, although some stalwart places remained true to the original cause and offered little more than a bar stools and shot and beer glasses.

Such was one of Hamtramck's legendary bars.

Jim Yarema holds up his framed diploma from Columbia. "I graduated from Columbia," he beams. "I passed the bar."

His major: People.

Jim and the whole Yarema family attended Columbia—that's Columbia Bar, which they owned from the late 1940s until they sold it to Lili Karwowski who turned it into Lili's 21 in the early 1980s. But for those forty-some years, the Yaremas got a lesson on living that few outside that dim interior could experience—or even imagine.

The Yarema family—Jim, Terry and Gerald—learned a host of life lessons during the time they operated the Columbia Bar, as attested to in the degree they got from "Columbia."

"We had a lot of action there," said Jim. Much of it was typical for what you'd expect in any Hamtramck bar. But a lot could have been penned by Damon Runyon, who was known for his cast of colorful New York characters, like Benny Southstreet and Harry the Horse. But the Columbia was set on Jacob Street in Hamtramck just off of Jos. Campau Avenue, and the characters includes the likes of Lizzie the Rat, BO (Benny Onions), John Guggenheimer (named as such for his favorite whiskey), and many more.

"All the Goodfellas came in the bar," said Terry Yarema, Jim's younger brother. They drank, they played the numbers and they placed their bets in the blind pig that was comfortably housed inside.

Terry remembers growing up in the Columbia. His bedroom was upstairs, just above the jukebox. There was one guy, he recalled, who was obsessed with the song "Running Bear" (Johnny Preston, 1959: "Running Bear loved Little White Dove with a love as big as the sky ... " Now you remember?) This guy loved Little White Dove too, to the tune of playing it endlessly on the jukebox. "He played it over and over," Terry said. Back then you'd get six records for a quarter. He'd put in four quarters—that's 24 Running Bears in a row. "I used to go to sleep in that," he said. "I grew up in noise."

"We had all kinds of people coming in," said Jim. "You get to learn a lot about people."

Another favorite was a guy named Joe, with whom they used to go fishing. "He moved so slow that he wouldn't make a splash if he fell in the water," Jim said.

Lizzie the Rat was a good friend, but he was not a person to trifle with. He's buy debts. Say somebody owed you $500 but couldn't or wouldn't pay. Lizzie would buy the debt from you for $200, so at least you got something, then he'd go out and collect the full amount from the deadbeat.

One day he showed up at the gate of the Chrysler Plymouth Road plant just outside of Hamtramck when the shift ended, pulled a gun and stuck it into a guy's face telling him to pay up. Well, that sparked a conversation and by the time it was done, Lizzie had sold the guy his gun. Of course, he was sharp enough to unload it before concluding the transaction. "He said he'd send him the clip later," Terry said.

Then there was the local doctor, who shall remain unnamed, who was not above performing some medical procedures in the bar.

Gerald Yarema, the senior brother, remembers the guys who would drink, but only if the bartender would drink too. That was bad for a whole lot of reasons, but Gerry learned to take a bottle of ginger-ale, shake all the fizz out of it and pour it into a whiskey bottle so he could drink away with no unwanted effects.

Being responsible bar owners, the Yaremas would drive some customers home when they had too much to drink. But, as the saying goes, no good deed goes unpunished, and they soon discovered that helping the drunk up the stairs into his home could be perilous. Often an angry wife would be waiting and armed with cups and other household items that she would let fly as she cursed the soused spouse.

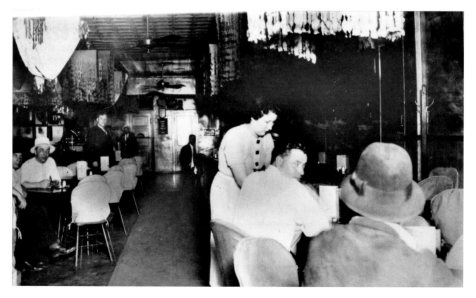

Columbia Bar was housed in a building that likely is the oldest bar building in the city, dating from the 1890s. Columbia Bar evolved into Lili's bar.

"I learned to push the guy into the wife's arms when she opened the door," Terry said. "That way I could run down the stairs before she could throw anything."

Whether that qualified as a life lesson is debatable, but some valuable lessons were learned. On one occasion a man and young lady came to the bar, and for whatever reason the man was rude an obnoxious to the point that Terry told him to leave. Three days later, dad Michael Yarema, walked into the bar with the same guy, treating him like an old pal. In an awkward position, Terry asked to see his dad privately and told him of what happened.

To his puzzlement, dad asked, "How many pork chops do you eat?"

"What?" Terry asked.

"I know you eat six. Well, you're gonna eat four, because that guy buys the pork chops."

What did it mean? The customer pays the bills so forget your personal feelings. Terry quickly made his peace with the guy.

"Kids in school get book smarts," Terry said. "Working in a bar gives you street smarts. I'd rather be a graduate of Columbia Bar than Columbia U."

Some bars also reached out by sponsoring various amateur sports teams, which amounted to the bars paying for uniforms bearing the bar's name, and in return the team members frequented the bars, spending money there after the games. It was, appropriately, a win-win arrangement even if the team lost-lost. Sponsoring sports teams goes back at least to the mid-1930s, when Paddy McGraw backed a baseball team. In 1949 Congor Bar, on Conant Street, sponsored a championship bowling team in some league at the time.

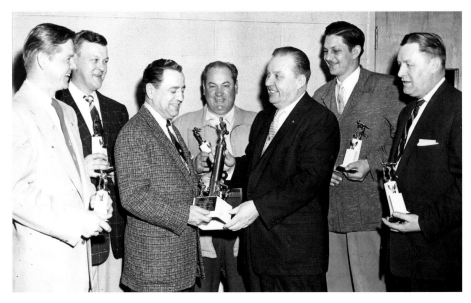

Mayor Al Zak presents a bowling trophy to Edmund Orlowski, owner of Gensey's Chop House in 1955. Many bars took up sponsoring sports teams as a way of building a guaranteed customer base.

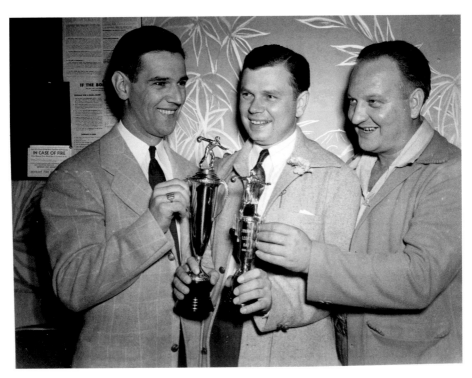

Bar owner Johnnie Lega (center) receives a sponsorship trophy from Al Blum (left) and Walter Paspiech for a championship bowling squad in June 1942.

Other bars took a somewhat different approach to sports. Back in the 1940s and 1950s when Hamtramck High School had a legendary football rivalry with Detroit Catholic Central High School, Keyworth Stadium would be packed with 8,000 spectators for a typical game. Interest was intense and you could place your bet at one of the local bars, each giving their own odds on the game.

In any case, the idea was to have fun, and isn't that what bars are supposed to be all about? That's the way they felt at Macy's Bar in 1962 when it was known as the "Home of Good Fellowship."

Fellowship took on a whole different meaning at Edna's Cozy Corner, which achieved a degree of notoriety that was shocking for its time. Labeled "a known hangout for sex perverts" by a newspaper in 1950 it had the reputation of being a lesbian bar. Located on Conant Street on the far south side of town, Edna's hosted such diverse musical groups as the Polish band Kumotry and Evaline Hair and her Swingtime Cow Girls. It also was the site of a notorious killing in which an off-duty Hamtramck police officer shot one man to death while attempting to break up a brawl. It happened in September 1950, when Joseph Krass, 21, claimed that a Detroit man, Harry Robinson, gave him "a dirty look"

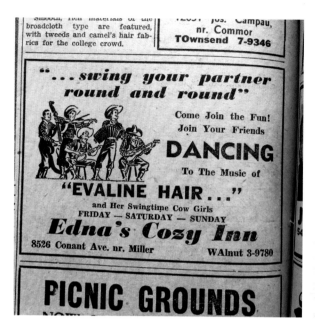

broadcloth type are featured, with tweeds and camel's hair fabrics for the college crowd.

nr. Commor
TOwnsend 7-9346

"... *swing your partner round and round*"

Come Join the Fun!
Join Your Friends

DANCING

To The Music of

"EVALINE HAIR ..."
and Her Swingtime Cow Girls
FRIDAY — SATURDAY — SUNDAY

Edna's Cozy Inn
8526 Conant Ave. nr. Miller WAlnut 3-9780

PICNIC GROUNDS

Edna's Cozy Inn seemed innocent enough when it advertised dancing in 1950. In fact, the bar was embroiled in controversy as it had been identified as a lesbian bar, and was the site of a notorious attack on a police officer.

inside the bar. Krass invited Robinson to step outside and when he did, four of Krass' pals, supposedly from the Harper-Van Dyke gang, jumped Robinson.

In his upper flat in a house next to Edna's, patrolman Stanley Supina was getting ready for bed when he heard a commotion outside. Looking out the window, he saw the men beating Robinson with beer bottles. Robinson by this point was on the ground. Supina grabbed his gun and badge and ran outside. Accounts of what happened next vary a bit, but apparently Supina was immediately slammed with a fist to the chin by Krass who turned and ran. Supina, however, held the other men at gunpoint while his wife in the apartment called for police backup. Suddenly the men turned on Supina and came toward him menacingly. Supina threated to shoot, but was attacked from behind by Krass, who was swinging a 16-inch wrench. "He was like a maniac," Supina said.

Krass kept swinging, and Supina shot him three times. Krass ran for a distance, then collapsed, dead. The others were arrested. Supina was taken to a hospital for treatment. At the time, Krass was on probation for beating another policeman at Frontenac and Strong streets in nearby Detroit. None of this sat well with the common council. No doubt Edna's Cozy Corner's reputation had already tainted it in the view of many in those more sexually conservative times. And there was an issue with the bar serving minors. Following Prohibition the drinking age in Michigan was set at 21. Several members of the Harper-Van Dyke gang were under age 21 and they had been drinking in Edna's. Within a week of the Krass shooting, Councilman Henry Kozak asked Edna's to leave the city. That came about as representatives from the Michigan Liquor Control Commission questioned the

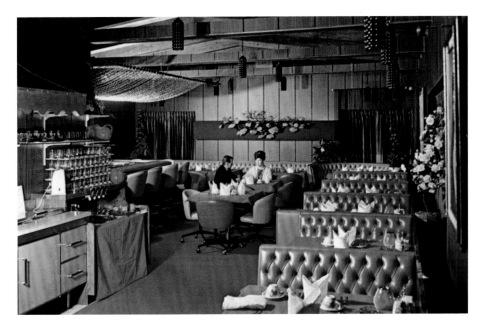

Edna's Cozy Inn wasn't the only bar to serve up more than drinks. The Robin's Next Inn housed in the Berkshire Motel was notorious for the prostitution busts police conducted there. It was on Jos. Campau Avenue right across from the Dodge Main factory.

Harper-Van Dyke brawlers, who admitted being served at Edna's despite being underage. In November 1950, the Michigan LCC fined the owner of Edna's $200 and ordered her to sell the place within 60 days for serving minors. The owner appealed the decision but in January 1951, the appeal was rejected and the fine and order to sell within 60 days was reaffirmed. Thereafter the bar drifted into history almost without a trace. In 2017 the house Supina lived in was long gone and the building that housed Edna's was serving as an Arab poultry and fish market.

Even as Edna's was undergoing its troubles, all of America was experiencing some wrenching times, but in a gentler fashion. Beginning in about 1948 America underwent a cultural change of titanic proportions that would have a unique impact on bars. It actually began in the fall of 1947 when the fledgling NBC television network broadcast the World Series. Suddenly people far from the baseball field were in effect given tickets to the hottest sports event there was. For free. Baseball fans who dreamed of going to the World Series were allowed, in a way, to do just that.

Although network TV broadcasts at that time were limited to New York City, Philadelphia, Schenectady, N.Y., and Washington, D.C., some 3.9 million people viewed the World Series, and their response was phenomenal. It became instantly clear that people wanted more, so within a year the lineup of TV programs went from a skeletal patchwork of a handful

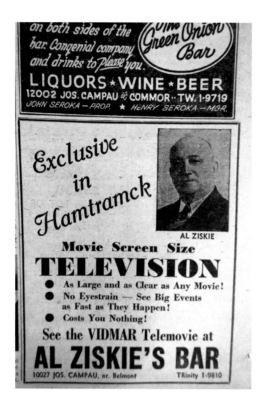

America virtually adopted TV after the 1947 World Series was broadcast. While few people could afford TVs at first, bars could. And soon TVs were a big draw in bars that vied for having the biggest and best TVs for viewing.

of shows each week to a full slate of prime time programming, 7 to 11 p.m., seven days a week, as stations were established across the country.

To see TV was to love it. The only problem was seeing it. Almost no one west of the East Coast had TV sets. But department stores did. They would put them in the showroom windows where people would gather outside to watch. The people wanted TVs but they were expensive. A 15-inch model could cost a whopping $895. That's $8,966 in 2017 dollars. Even so, sales skyrocketed. The Muntz store in town opened in October 1950, and sold so many TVs that by April 1951, it moved to larger quarters to accommodate the rush of buyers. In moving, the store announced it had done "a half-million in business" in those seven months selling TVs.

While great for Muntz and other department stores, this was absolute murder to the local theaters, which withered and died by the tens of thousands across the nation. Almost at once, people weren't going to the movies two or three times a week anymore. They were staying home watching "I Love Lucy" and Uncle Miltie. Bars were quick to latch onto the potential draw of TV sets. A good indication that they were a match came early on with the 1947 World Series. As noted, 3.9 million people watched the World Series. Of those, 3.7 million watched in bars.

In 1949, Richie's Bar, on Evaline Street at the corner of Charest Street, advertised "Television every day." The bar even held "Afternoon television parties." The bar supplemented the TV shows with performances by Joseph Gburzynski, "The Accordion Soloist" who played the "finest accordion music in town." Over at Johnnie Lega's Bar on Jos. Campau Avenue, the public was "cordially invited to see and listen to our television programs."

Caniff-Buffalo Bar told all it was "A friendly place. Everybody is invited to see and hear the latest in sports and entertainment on the television now showing daily."

Martha Washington Café made virtually the same claim: "Everybody is invited to hear and see the latest sports event now. We now have the largest U.S.T. Television in Hamtramck." (U.S.T. was United States Television Manufacturing Corp., a maker of early televisions.)

Playdium Bar touted that it had a 20-inch TV available for watching daily.

A 20-inch TV set made viewing by crowds in bars a challenge, but for bars that could afford it, U.S.T. had a model with a five-square-foot projection screen available for $1,795. But that probably was out of the reach for most Hamtramck bars.

Al Ziskie bragged that his television was projected on a movie screen using a process called Vidmar Telemovie. It provided clear, well-defined images "as fine as in the movies." And his place was the only one in Hamtramck to have it. That must have replaced an earlier system he employed using one of the early TVs that had a small round screen. Ziskie devised a pulley system so that he could turn on the TV and set it to the channel he wanted, then hoist it up to the ceiling so everyone could see. It had a large magnifying glass attached to it, which was common for those small-screen TVs in the early days. Former Mayor Bob Kozaren recalled seeing the Rube Goldberg-style contraption in action. "It was blurry," he said, "but it was good to watch."

Bars and televisions have remained wedded ever since those early days, despite the fact that in the 1950s TV set sales for homes grew greatly. Often, it was just one neighbor on the block who got a TV. Neighbors would congregate at that person's house to do the viewing. Sometimes they would gather on the front porch, watching the set through the open font door. In April 1950, there were 5.3 million TV sets in American homes. By October 1950, there were 8 million. By 1959, 42 million American households had TV sets, some more than one.

Today, it's still common for bars to have TVs, often multiple sets, especially in sports bars where a ridiculous array of games and events may be on screens all over the place.

But so what? It all contributes to the fun.

Music, however, followed an even more dramatic path.

5

THE BEAT GOES ON

"The vibe was in the air."

That's how Charles "Chip" Sercombe described the feel of the town back when the local music scene was blisteringly hot. Later, in 2017, Sercombe is editor of *The Review*, Hamtramck's local newspaper. But back then, he played drums in the band Hysteric Narcotics, which was most appropriate for the era as the beat of the music could be overpowering and there were a few drugs floating around. It was the mid-'80s when the Hamtramck music scene was flourishing. That had taken root a decade earlier when the wounds of the Vietnam War were still fresh. The Hippies were gone but the turmoil of Watergate lingered. Like always, people, especially young people, were looking for something, although exactly what was elusive.

But whatever it was, it was there in Hamtramck. "We really learned to play in Hamtramck," Sercombe said. The Hysteric Narcotics performed just about every weekend, usually rotating between Paycheck's Bar on Caniff Street near Jos. Campau Avenue and Lili's 21, a bar that was to grow to majestic proportions in Hamtramck's music scene. They also would play at Hamtramck Pub, father down on Caniff Street where "it was wall-to-wall people," Sercombe said. And it was different. "It was a real eye-opener for a suburbanite," Sercombe said, who transplanted to the area from the East Coast, and then Livonia, a nearly pure-white suburb west of Detroit. At a Hamtramck spot, you'd meet everyone, all races, genders and those in between. They mixed "shoulder to shoulder" on the dance floor. It was crowded, noisy and grungy—exactly what the music fans wanted, for the most part. But it was so different, some had trouble accepting it all.

"Some of the people I went with were freaked out," said Walter Wasacz. Wasacz was born in Hamtramck and knows as much about the Hamtramck music scene as anybody could.

Wasacz was already into music by the mid-1960s when "Motown was the soundtrack of Detroit. Radio was playing Motown records all the time. About the same time, the Beatles hit it big and the British invasion began.

Above: Paycheck's Lounge became—and remains—one of the key musical venues in Hamtramck.

Right: A poster for Dez Dickerson performing at Paycheck's Lounge.

"I was there, like 9 years old. It was the right time for that to have an impact on me," Wasacz said. At that time there were renters living on the upper floor of the Wasacz home including a couple of teenage girls. "They were listening to the Beatles," and soon Wasacz was hooked. "From a very early time, 9, 10 years old, I was buying records," he said. "I was into Jimi Hendrix when I was 12 years old."

He'd buy the records at the Federal department store and a little later at Old Towne record store. He listed to CKLW and WKNR—"Keener"—on AM radio. "They would have lists of records, like the top 13 or top 20 in this market—Detroit and Windsor. It influenced and inspired a lot of people around the country (CKLW especially had a huge broadcast range, reaching into Middle America) with what they played."

Around that time, the late '60s, "young guys who were a little older than me were starting bands ... they were wearing their hair long ... wearing plaid pants. I thought this was cool. There are many reasons that Hamtramck is cool but I thought that at this point in my life, when I was 11 years old, I was learning about the world. There was a world out there with the Beatles and the Rolling Stones, and seeing what was happening in my neighborhood was really an eye-opener."

As the Vietnam War heated up, music became part of a social movement, Wasacz said. Garage bands were forming everywhere and many an alley thumped to the beat of a

Fliers—some quite crude and some professionally done—were a principal means of publicizing bands playing at the bars in the days before Facebook. Here Nikki and the Corvettes are promoted coming to Paycheck's Lounge.

would-be band that practiced seemingly endlessly in the space where the car should have sat. Most went nowhere, but some began to emerge from the clutter of noise. Bands like the Rockin' Levis and Shazam stared by playing in teen clubs, which basically were dances held at one of the numerous local halls like the Ukrainian Workers Home on Carpenter Street, just at the city's northern border with Detroit.

In time the bands shifted to the bars. "It was like a marriage of bar owners and bands that were active at the time," Wasacz said. But it wasn't a comfortable arrangement. "At the time almost every band in the city of Detroit that played in bars was a cover band. They'd play Bachman-Turner Overdrive, whatever, but they were not playing their own music. Nobody wanted to hear original music. Everybody would go out and dance to the hits played by a band who knew almost note for note how to play very accurate presentations of the hits of the day. But these bands began to develop their own sounds."

A "Hamtramck sound" began to form. "It had a sound that was different," Wasacz said. "So bands like the Mutants, Romantics, Reruns all had a common thread. You could tell they listened to the same kind of records. And growing up in Hamtramck they all had a kind of fraternal thing going on. Some went to St. Lad's (St. Ladislaus High School) and some went to St. Florian. Some went to high schools outside of the city. But there were a fair number of musicians who kept playing throughout the '70s and '80s.

A pivotal moment for the bands and the music scene was the opening of Misty Inn on Jos. Campau Avenue in the mid-1970s. "There was no other place like it," Wasacz said. "We'd go there on a Wednesday night and see friends there and play the jukebox and drink beer. Then on Saturday we'd go and it would be packed, just packed. I remember meeting a bunch of women coming from Warren. People who had lived, who had moved from Hamtramck or who had some kind of relation to Hamtramck who lived in Warren or Sterling Heights would come back. They would become part of the Hamtramck family in terms of the music scene."

The Misty Inn was instrumental in featuring local bands that played their own music rather than covers of hits. "They had bands that were writing their own songs, performing their own songs."

Another place that quickly grew in popularity was Bel-Con Lounge, on Conant Street and Belmont Street. You could see Kompanie and later the Reruns playing there. Bel-Con Lounge morphed into The Bowery, which had no connection to the original Bowery night club, but through the late '70s was a key music venue. But by then it wasn't the only venue. A couple miles to the northwest on McNichols Street just west of Woodward Avenue in Detroit, Bookie's Club 870 opened in 1978. The Sillies, The Romantics, Destroy All Monsters and many more bands virtually took up residence there, and some major names in the business, like Iggy Pop and Blondie, were known to stop by. For a lot of local folks, when things were too quiet in Hamtramck, Bookie's was the place to go. Even when the action was hot locally, Bookie's was a powerful draw. But as time went by, more bars in Hamtramck were adopting live bands. As music evolved in the late 1970s, disco appeared

The Bowery—no relation to the classic night club of the 1940s—promoted its acts with handmade fliers.

on the scene—for better or worse. Disco was divisive in a way. Some people loved it, purists hated it. "It divided people," Wasacz said. "There were a lot of rock 'n' rollers who detested disco. In the crowd I was running around with, there was a great split." (Our Friend, the Drinker loved disco and took great pride in his white suit.)

Hamtramck sported at least one bona fide disco. In 1977 the second floor of White Star bar on Conant Street was converted into a "world of flashing lights, mirrored walls and gyrating sounds," or so it was described in a newspaper story at that time. It boasted 500 lights, a 24-foot by 16-foot dance floor, a mirrored globe and "a causal dress code." You had to climb fourteen stairs to get there and the dancing was only Wednesdays through Sundays. But it was open until 2 a.m.

And yet ironically, it also was a unifying sound. Black and white, and especially straight and gay, found common ground on the disco dance floor. But for some, the culture shock was too much. Remember, many of these wild and crazy kids writhing to the sounds of an insane beat were bred as good Catholic boys and girls with some rigidly conservative perspectives. They couldn't deal with the sexual diversity.

To a large extent, "it was the Catholic underpinnings of the city," Wasacz said. "It was something there. I could see it. I could feel it." And, remember, this was the 1970s, not the 2000s. But for everyone who couldn't take it, there were many more who thrived to the beat and even

A more sophisticated flier advertises Nikki and the Corvettes performing at The Bowery. Groups often rotated through venues across town.

reveled in the anti-establishment concept of it all. This was likely even heightened with the arrival of punk rock, a style of music that took direct aim to all that was sacred among good, upstanding, God-fearing citizens. How else could you describe the Sex Pistols' "No Future."

It was into this audio anarchy that Lili's was born.

Technically, it was Lili's 21, but there was really nothing technical about it. Set on Jacob Street, just east of Jos. Campau Avenue, to some it was a dive with all the charm of an abandoned building, which it wasn't, although it did resemble one in some ways. But it also was a glorious cathedral devoted to cutting edge music.

Art Lyzak described it as a "clean and comfortable dive." Art is the son of Lili Karwowski, founder of the place. For years he ran the Lili's with brothers Chris, Steve, Alan and Michael Karwowski. It all started in about 1975.

"Prior to getting Lili's, she worked at the Port Bar and the old New Dodge Bar," Lyzak said of his mom. "Prior to that, in the mid-'60s, I had a band, the Rockin' Levis, and Lili would occasionally throw teen dances at the PRCU (Polish Roman Catholic Union) or at the hall on Klinger that became Motor (the old Polish Falcons hall). Since they were very successful gigs, I remember going with her to look at the boarded up Conant Theater to possibly buy it for more shows. But the building, especially the roof and ceiling, were a mess. She passed."

At one time, White Star Café Club sported a disco on its upper floor. Later it took on a more, shall we say, "urban" look.

The latest incarnation of White Star as a night club. But there's more to this view than a building. Note the Muslim woman walking past. She is indicative of the changing demographics of Hamtramck, which is becoming increasingly diverse, including Muslims, who do not partake of alcohol.

It wasn't much to look at, but Lili's became one of the key focal points of the music scene for the whole metro Detroit area. Some of the most cutting-edge bands played there.

Lili's took its cue from Bookie's Club 870, a popular place in Detroit. It too featured some of the hottest bands around, including the Romantics.

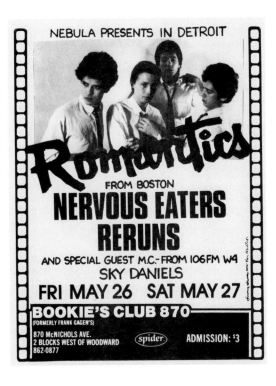

NEBULA PRESENTS IN DETROIT

Romantics
FROM BOSTON
NERVOUS EATERS
RERUNS
AND SPECIAL GUEST M.C. FROM 106 FM W4
SKY DANIELS
FRI MAY 26 SAT MAY 27
BOOKIE'S CLUB 870
(FORMERLY FRANK GAGEN'S)
870 McNICHOLS AVE. spider ADMISSION: $3
2 BLOCKS WEST OF WOODWARD
862-0877

Lyzak had other experience with the musical scene. Along with the Rockin' Levis, he was with a band called the Mutants, which often played at Crest Lounge in Hamtramck. He also made a number of trips to New York looking for a record deal. "I saw how New York City bars were starting to feature live, 'original' music, specifically C.B.G.B.omfug (Country, Bluegrass, Blues and Other Music for Uplifting Gormandizers), a dive bar in the Bowery. I tried selling Lili on the live original music idea but she wasn't buying it until 1979 when I took her to Bookie's. They used the CBGB model and made it work. I told Lili we could make it work in Hamtramck, too. She finally agreed."

Lyzak also was a member of the band called Surfin Bootsey & the Tse Tse Flies, "and since I was one of the Tse Tse Flies we were the first band to play the Lili's stage. A few days after that gig *The Detroit News* did a story about Bootsey X (musician Bob Mulrooney), the Tse Tse Flies and the Kowalski (company) neon (sign). It was like someone flipped a light switch. A lot of music fans started coming to Lili's. Our special was shots of Kessler for 50 cents. And Lili was a great fan of pouring *Jezynowka* (Polish brandy), which was nicknamed Rocket Fuel and Stupid Juice.

"Once the '80s rolled around my brother Alan started bartending nights and came up with a pale blue milk shake-like drink called the Valium, which won many drink awards. Our brother Mike ended up bartending, too. It was in '79 or '80 that Iggy Pop came in for a drink, then the Clash after a Detroit concert. (Clash member) Joe Strummer was carried out to the tour bus after Lili plied him with Rocket Juice.

"Before he was a superstar Bruce Springsteen was turned away at the door because Lili didn't know who he was and the bar was way too packed. Kelsey Grammer, Jack Wagner, Elmore Leonard, Lene Lovich and many other celebrities would visit. The live music, the cool jukebox, which was named the 'best jukebox in America in the book *Jukebox America*, cool and cheap drinks, the Hamtramck vibe and, of course, Lili, made it a fine night out for many years."

Other big name bands that played there include the Stooges, MC5, Mitch Ryder, White Stripes, Rhythm Corps, Sponge and even the Goo Goo Dolls.

Little wonder that Lili's grew to be so popular with so many. Locals and those from the suburbs and far beyond regularly made pilgrimages to Lili's. There hadn't been anything like it in Hamtramck since the days of the original Bowery decades earlier. Lili's began to attract more wide-ranging attention as it was featured in *Rolling Stone, Spin* and *High Times* magazines. Even AAA publications listed it as a must-see destination in the Detroit area. After all, you just might run into "Weird" Al Yankovic there—although supposedly he said "no, it's not me" even before anyone asked him.

As for Lili, for many she was the loud, fun-loving brassy lady who knew how to party. "She was also warm, funny and genuine," Lyzak said. "I appreciated the fact that everybody loved Lili. Many confided in her and called her mom, too. She really enjoyed drinking and laughing with new and old friends. She was a great friend and mom to me. And her potato pancakes and *golabki* (cabbage rolls stuffed with meat) were to die for."

A crowd gathers at the door of Lili's. The bar became so popular that at times it was filled to capacity. [*Christopher Betleja collection*]

When Lili died on December 22, 1999, it was a local tragedy that drew even the attention of city hall. Mayor Gary Zych sponsored an official resolution noting that "Hamtramck suffered a loss of a most cherished neighbor, highly esteemed proprietor, legendary hostess, patron of the arts and an irreplaceable blue-collar role model, Maria 'Lili' Karwowski of Jacob Street, whose soul has absented itself from us to be present with the Lord for all eternity."

It went on to praise her as "Hamtramck's Polish Diva" and said she had been adopted as "a Hamtramck surrogate 'mom' by assorted garage band musicians and others of various musical persuasions including but not limited to that of rock, rockabilly, rock/polka, punk rock and other eclectic sensibilities, while establishing for herself a sartorial reputation for flamboyant leopard skin animal prints."

"To know her was to love her," it concluded, "and we know that Lili loved and will always be loved by her hometown, Hamtramck."

After Lili died, the kids kept the bar going for a few years. Alan Karwowski even was named the area's top bartender for two consecutive years by the *Detroit Metro Times*. "I'm proud of that," he told *The Citizen* newspaper in 2002, as Lili's closed its doors. "I'm more proud that Lili's had a good, sincere—and honest—25-year run."

But Lili's without Lili just wasn't Lili's. In September 2002, it announced it was closing. And that last night was one to remember—if you could. People were packed door-to-door and

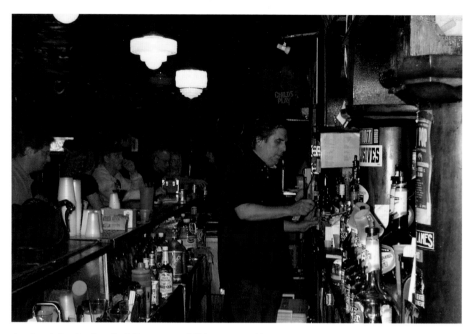

Art Lyzak has his hands full serving a full house at Lili's.

There were times when Lili's was so crowded it was difficult to even get to the bar to order a drink.
[*Christopher Betleja collection*]

When Lili's founder Lili Karwowski died in 1999, Hamtramck Mayor Gary Zych proposed an official city proclamation honoring her and her legacy including being "an eminent musical ambassador and trans-generational figurehead" for the city.

spilled outside. Gail Uchalik, wife of Dave Uchalik, of the Polish Muslims, one of the most popular bands still playing in Hamtramck, was there. She recalled: "It was so much fun. You went back in time. It was packed, the bar was four deep and you couldn't get a drink. People were turned away at the door. It was just so exciting, so bitter sweet because it was closing."

"Lili's was special," said Christopher Betleja. "It was almost like a freak show, with their colored hair and weird styles. But you got to know the freaks."

Betleja admittedly spent a lot of time in Hamtramck bars but has come through the experience remarkably well. He's seen it all. "I watched them throw people out at gunpoint (at Lumpkin-Faber Bar)." He played the jukebox at Shy & Red's bar, which catered to the Chevrolet Gear & Axle plant workers, and would have drinks lined up on the bar waiting for the workers when they rushed in during lunch. He went to Mr. Joe's where the bartender would never give a free drink—or ever accept a tip. And he knew a lot of the characters, like Doughboy, who worked as a meat packer; The Fly, who had jerky movements and "fought the air"; Paula the Dog Lady; and Stefan, who was the most well-known customer at Lili's. An old-time Polish immigrant, Stefan spoke broken English and had the trademark line "y-you buy me beer," said with a slight stutter and heavy accent to anyone who would listen.

But perhaps the most memorable moments were at Lili's. He remembers when Iggy Pop signed autographs there. "He got so many requests he signed a bunch and threw them into the air, sending people clambering for them.

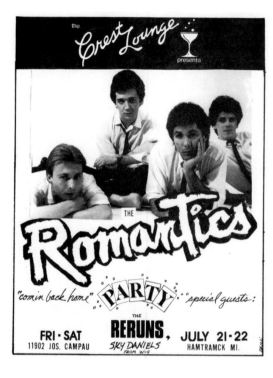

Left: Crest Lounge on Jos. Campau Avenue was another leading spot for the music scene when it was hot.

Below: Crest Lounge really did get hot. It met a fiery end, a fate that happened to a number of bars.

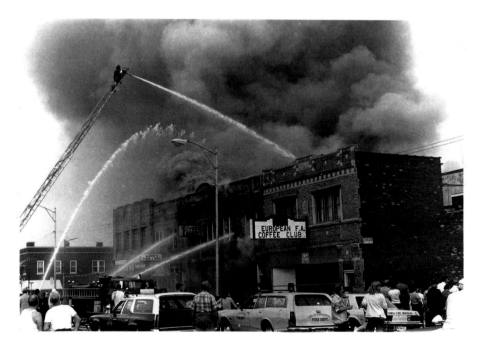

"It was totally revolutionary what was happening there," Betleja said. Lili's was the place to go to when you wanted to get a little wild.

And after a long night of bar hopping, "you would go to The Clock." That 24-hour restaurant on Jos. Campau Avenue was perfectly situated as the place to decompress and sober up before heading home as the sun rose.

As successful as Lili's was, it didn't own the music scene. Motor, Small's, New Dodge, Crest, Kelly's and others offered a full range of music. But two places in particular stood out: Paycheck's and Attic Bar, although they were very different in concept. Paycheck's was—and is—closer to the concept of a Hamtramck bar—loud, crowded and a bit grungy. But the music is unbeatable, even today. At one time Paycheck's was voted "the best place to hear alternative music," by *Real Detroit*, a Detroit alternative newspaper.

"It was bigger than Lili's, bigger than any of the other places," said Wasacz. "They had a nice stage." And he noted Paycheck's was in a good position when the Detroit garage scene began developing in the 1990s in the Cass Corridor in Detroit. Bands like the White Stripes were on the rise. "They played at Paycheck's several time." As of 2017 Paycheck's was still going strong.

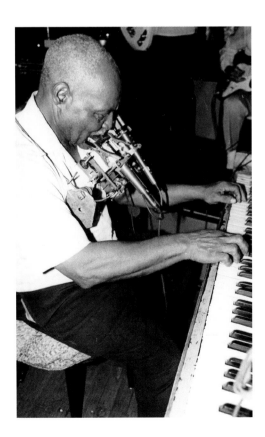

Uncle Jessie White played the blues while he was well into his 80s at The Attic Bar. It became known as one of the best blues bars anywhere.

But you wouldn't expect to hear punk rockers or garage bands at the Attic Bar. It became legendary for the blues. Uncle Jessie White was virtually a fixture there well into his 80s. The Butler Twins played there for at least ten years, along with Duke Dawson & Friends and Sweet Claudette. Mondays were set aside for "experimental blues" with a new band every month. The focus was on delta blues, with its early basic structure straight from Mississippi River country, and those who know about blues say there was a lot of reverence shown for the music there.

It stood in sharp contrast to the raucous rock being played in other bars, but as small as Hamtramck is, there was plenty of room for all makes and styles of music. In time, however, the sounds faded. The Attic Bar went under new ownership in 2006 and the building got somewhat of a facelift from its "1970s-era biker bar" look, as Sercombe described it. But it just couldn't hold on and closed not long afterwards.

Yet the loss of even such a cornerstone bar like the Attic didn't devastate the local music scene. In fact, it grew in a new dimension. In 1997, the *Detroit Metro Times* launched the Hamtramck Blowout, which would expand to become "the largest local music festival in the nation," according to the *Metro Times*. This was as four-day music event staged at dozens of locations in Hamtramck including the bars, and later such diverse spots as the Polish Legion hall on Holbrook Street and the Fowling Warehouse on Christopher Street. (Fowling is weird local game that is a cross between football and bowling. You throw the football at the pins. And drink beer.)

Forget rock 'n' roll—Motor Lounge had the Hot Hungarian and Transylvanian Folk Dance Party.

The Hamtramck Blowout quickly grew to mammoth proportions. Dozens of bands including hundreds of musicians took part at a couple dozen venues. Here you could hear bands like Blue Snaggletooth, Jet Black Blonde, Cheerleader, Cold Blood Club, The Howling Loud, Fake Surfers, Lizerrd and many, many more. As many as 5,000 people would attend the Blowout. Unfortunately, it just took one person to nearly torpedo the entire event. In 2012 four women coming out of a bar late one night were carjacked and assaulted. The resulting publicity was devastating. Even though tens of thousands of people had attended the Blowouts for years without any major incident occurring, the stigma of being located in inner city Detroit struck and struck hard. The Blowout attracted huge numbers of suburbanites, many of whom already had a fear of crossing Eight Mile Road into big, wicked Detroit, and this made all their bad dreams come true. In response, neighborhood security was beefed up. But that didn't ease their fears, so Chris Sexson, *Metro Times* publisher, announced the 2013 Blowout would be spread out beyond Hamtramck's borders. Venues would be split among Hamtramck, the "safer" city of Ferndale in Oakland County and in Detroit.

It had to be done, Sexson said. "Going to Hamtramck was outside of some people's comfort zone," he wrote. Safer, indeed. Like what could be safer than the Ferndale Public Library, which was announced as one of the venues.

What a concept: The Hamtramck Blowout at the Ferndale Public Library. But it was the "comfort zone" comment that drew the ire of the city, especially when stock was taken after the event and the bar owners, who would know best, said attendance was significantly lower during the week the Blowout was held in Ferndale. Still, what happened happened, and there was no denying that the incident soured some out-of-towners from coming to Hamtramck. Even some musicians expressed concern that it wasn't safe to bring their instruments to town.

But spreading the Blowout to the suburbs was enough to prompt outrage in Hamtramck, which it indeed did. In short order plans were laid for a Hamtramck Music Festival, which seemed to have the theme: Screw you, *Metro Times*.

Outwardly, though, it wasn't presented that way. Organizers of the Hamtramck Blowout said they wanted to fill the gap in the traditional early March timeslot that had been occupied by the Hamtramck Blowout. The new *Metro Times* Blowout was moved to late April, early May when the weather was warmer. The Hamtramck folks said they wanted to keep the festival in early March as it always had been. It was presented as kind of like moving Christmas to June. Not having it in March was a "loss." The new Hamtramck Music Festival took off fast, with 256 bands playing at seventeen venues in town, and that success may have soothed feelings all around.

The March 2, 2016, issue of the *Metro Times* featured the cover story on the bands to watch for in the upcoming Hamtramck Music Festival, entitled "12 acts not to miss at Hamtramck Music Festival 2016" and the subhead, "A sweaty good time awaits you in

Above: Lush added a new dimension to the bar scene with its free dance lessons and Salsa Sundays.

Left: While many Hamtramck bars became trendy in the 1980s and 1990s, some, like Kelly's Bar on Holbrook Street, remained close to its traditional corner bar roots. Kelly's remains one of the oldest bars in Hamtramck, dating back at least 50 years.

lovely Hamtramck." Perhaps the key sentence in the story was, "There are no hard feelings between the *Metro Times* and the Hamtramck Music Festival."

Of course, in the true spirit of Hamtramck, some sour notes were sounded in subsequent festivals, including the withdrawal of some booked bands in protest over two bands, one deemed as sexist and racist and one harboring a registered sex offender. Both bands were removed from the roster and the festival planners adopted a "zero tolerance policy" regarding harassment of any type. That wasn't enough to satisfy some of the parties involved but the 2017 Hamtramck Music Festival went on pretty much as planned and drew some 4,000 visitors to see 180 bands at 22 venues. Those numbers did much to redeem Hamtramck's reputation and showed that the city still had tremendous drawing power from across the metro area.

As for the *Metro Times* Blowout, no plans had been announced for 2017 and the only mention in the paper was in reference to the Hamtramck Music Festival, which "began in absence of our own Blowout Festival (RIP)."

Festivals come and go. So do bars. Some change owners, names or just go out of business. And some live on even after they are gone. Such is the case with 7 Brothers Bar. For much of its relatively long existence on Jos. Campau Avenue, it was known for virtually nothing.

"It was a hole in the wall," said Darren Shelton, who came to appreciate it. For some reason it appealed to the cast and crew who operated Planet Ant, the local theater that opened on Caniff Street in 1993 as a coffee house, then converted to a live theater in about 1996. "It was just a place where you could go," said Shelton, "an artist, musician, performer, thinker, builder and creator" who opened the expanded Planet Ant facilities in the Polish Roman Catholic Union hall across from the original building in 2017. Soon after the Planet Ant people began frequenting Seven Brothers, the owner began hanging their face photos on the wall, kind of like Hamtramck's version of the famous Sardi's Restaurant in the theater district of Manhattan, but maybe with just a tad less class.

Anyway, the actors loved it, and they joined the 7 Brothers family. When the owner decided to retire in 2016 he offered to sell the bar building to Shelton as a modest price and Shelton said he couldn't let the building go. He moved the bar, pool table and iconic 7 Brothers Bar neon sign to the new building and equipped it with the transferred liquor license. They will be put back into service. And in that way 7 Brothers Bar will endure.

Such is not the case with most other bars. Many disappear into history without a trace except in the memories of long-time patrons.

But nothing remains static. For Charles Sercombe the music faded. "I decided to give myself a number of years to be a musician," he said. "Plan B was always to go to college." He did—Eastern Michigan University, where he studied journalism. Eventually he ended up at *The Hamtramck Citizen* newspaper, the predecessor of *The Review*, and has remained with *The Review* as editor for 20-plus years. Wasacz continues to write for a host of outlets, including a column for *The Review*.

Above left: Darren Shelton rescued the pool table from the old 7 Brother Bar and will preserve it at Planet Ant's expanded facility on Caniff Street.

Above right: Jerry Lega's place focused on food even while music dominated the bar scene.

Outer Limits Bar was a Hamtramckan by adoption. Technically it was just outside the border of Hamtramck (hence the name) but it was a favorite of many Hamtramckans. It even had an outdoor wedding chapel.

As for the music scene in Hamtramck, it's not what it used to be. Just about everybody agrees on that. But the Hamtramck Music Festival is going well and the bands are playing on. And so long as people want to have fun, it's likely the bars will continue to rock ('n' roll) into the future.

Do You Recall ... ?

What was your favorite bar?

Did you like the music scene, or the place where you could meet your pals and solve the problems of the world?

Here's a by no means comprehensive list of Hamtramck bars going back to the 1960s and indicating roughly the years they were most active. Note: Many bars changed names and ownerships over the years. The ones mentioned here are the most familiar.

So grab a beer, sit back and take a look. You may find some great memories.

Adam's Corner Bar: 1960s to 2000s. At Caniff and Lumpkin. It had a reputation as a rough place.

Alimony Bar: 1960s, on the South End on Jos. Campau Avenue. Ed and Stella Shekowski ran the place.

All American Bar: 1960s, on Jos. Campau Avenue.

Amy's Bar: 1960s, on St. Aubin Street.

Ann's Tavern: 1960s. On Sobieski at the corner of Commor Street.

Artie's Locker Room: 1980s, on Caniff Street. Owned by Artie May. And everybody knew Artie May.

Attic Bar: 1990s, on Jos. Campau Avenue, legendary home of the blues. Later became Metro Pub.

Baker Street Car Bar: Seemingly forever on Jos. Campau. Named for the street car line that used to run right outside the front door.

B&B Bar: 1960s, on Caniff. "Bill and Marty" ran the place.

B&H Bar and Grill: 2000s, on Caniff Avenue.

Bel-Con Lounge: 1980s, on Conant Street. A great music spot.

Belmont (Tavern) (Club) (Restaurant) (Sports Bar) Bar: 1960s, on Jos. Campau. OloMan coffee house moved into the space in 2017.

Bienkowski's Bar: 1940s-1960s, on Conant Street.

Bill's Bar: 1940s-1960s, on Conant Street.

B's Bar: 1960s, on Jos. Campau Avenue. Bill and Lillian Szebrowski, props.

Blue Goose Inn: 1940s-1970s, on Lehman Street.

Blue Jay Inn: 1960s, on Jos. Campau Avenue.

Blue Note Bar: 1960s, on Conant Street. Lee Porter, prop.

Blue Star Bar: 1970s, on Jos. Campau Avenue. Stanley Lipka, prop.

Border Bar: 1960s, on Carpenter Street.

The Bowery: 1970s, namesake of the great nightclub. This new version was on Conant Street.

Bristol Bar: 1960s, on Evaline Street.

Bruno's Caniff Bar: 1960s, on Caniff Street at Buffalo Street. Bruno and Josephine Zalewski, props.

B.S. Market Bar: 1980s, on Comstock Street.

Buccaneer Bar: 1970s, on Conant Street.

Bucciero's Bar and Dining: 1970s, on Jos. Campau Avenue.

Budd Benz Bar: 1960s, on Jos. Campau Avenue.

Bumbo's: 2000s, on Holbrook Avenue. Gets a lot of attention for its food, too.

Carbon: 2000s, on Jos. Campau Avenue.

Ciocia Pat's Bar: 1980s, on Caniff Street. Patricia Ciko, prop.

Columbia Bar: 1930s-1970s, site of the then-future Lili's.

Congor Bar: 1960s, on Conant Street.

Connie's Bar: 1960s, on Conant Street.

The Copper Penny: 1970s, on Conant Street. Formerly Uncle Al's.

Club Florian: 1960s, on Florian Street. "Ted & Irene Wisniewski, your hosts."

Club 77: 1960s-1970s, on Jos. Campau Avenue at the northern border with Detroit.

Connie's Bar: 1960s, on Conant Avenue.

Crown Bar: 1970s, on Jos. Campau Avenue, formerly Walter's Bar.

Ed's Market Bar: 1960s, on Comstock Street.

88 Ave: 2000s, on Conant Street.

Emily's Bar: 1960s, on Dequindre Street.

Eugene's Bar: 1950s-1960s, on Yemans Street at Lumpkin Street.

Frank's Bar: 1960s, on Lumpkin Street, Frank and Mary Browarski, props.

Gary's Bar: 1980s, on Carpenter Street. Gary Ciko, owner. Formerly Gary's Bar and Pattie's Kitchen.

Gene's Bar: 1970s, on Conant Avenue. "Go-Go Dancing."

Gensey's Chop House and Cocktail Lounge: 1950s-1960s, on Jos. Campau Avenue.

Goodtime Café: 1970s, on Jos. Campau Avenue.

George's Bar: 1960s, on south Jos. Campau Avenue.

Guy's Bar: 1960s-1970s, on Conant Street at Commor Street. Steak dinners $2 in 1967.

Hamtown Pub: 1980s, on Caniff Street, hot music spot.

Hank's Lounge: 1960s to 2000s, on Holbrook Avenue. Hank and Jean Krupinski, props. This earlier was Pek's Bar and in recent years is Bumbo's.

Happy Hour Bar: 1960s, on Conant Street, Chet Zembala and Alex Staszewski, props.

Happy Sam's Saloon: 1970s, on Botsford Street at Fleming Street. "Try our big boomba."

Head Coach: 1970s-2000s, on Conant Avenue.

Henri's Lounge: 1960s, on Jos Campau Avenue near Veterans Memorial Park.

Hippos: 1970s to 2000s, on Conant Avenue until it burned to the ground one night in 2013.

Jax Bar: 1940s-1980s, Conant at Caniff streets. Became Small's, a great music venue.

Joe & Carol's Lounge: 1980s, on Yemans Street.

Joe and Walt's Bar: 1980s, on Conant. Joe and Walter were Joe Kronk and Walter Olejniczak, props.

Johnnie Lega's Bar, 1930s to at least 1970s, on Jos. Campau Avenue. He also had a place in Florida.

Jerry Liga's Place: 1980s, on Dequindre Street.

J&S Bar: 1980s, on Conant Street.

Kelly's Bar: 1940s-2000s, on Holbrook Street. One of the oldest continuously operating bars in town.

Leaky Tap Saloon: 1970s, on Conant Avenue.

Lili's 21 Bar: 1980s to 2000s, on Jacob Street. Lili Karwowski's legendary punk/hard rock bar.

Lee T's Bar: 1960s, Jos. Campau Avenue and Commor Street.

Lela's Bar: 1960s-1970s, on Jos. Campau Avenue.

Leopolds's Bar: 1960s, on Jos. Campau Avenue.

L & S Bar: 1960s, on Caniff Street.

Lumpkin Faber Café: 1980s. Guess where it was located.

Lush: 2000s, on Jos. Campau Avenue at Trowbridge. Lots of great music.

Macy's Bar: 1960s, on Jos. Campau Avenue, "Home of Good Fellowship."

Martin's Café: 1940s-1960s, on Caniff Street.

Marvin's Saloon: 1960s, on Conant Street.

Metro Pub: 2000s, on Jos. Campau Avenue.

Midtown Bar: 1960s-1970s, especially known for its fish dinners.

Mister Joe's Bar: 1980s, on Yemans Street. Later became Whiskey in the Jar.

Misty Inn: 1970s, on Jos. Campau near Commor. Pioneering music venue.

Motor: 2000s, at the corner of Klinger and Caniff streets. Noted for techno and electronic music.

Mr. P's: 1970s, on Conant Street.

My Tavern: 1960s, on St. Aubin Street.

New Club 77: 1960s, on Jos. Campau Avenue.

New Dodge Bar: 1960s-2000s, on Jos. Campau. A speakeasy during Prohibition.

New National Bar: 1960s, on Hanley Street. Lenore Orlowski, prop.

Niczay's Bar: 1960s, on Conant Street. William Niczay, prop.

Norwalk's Bar: 1930s-2000s, on Conant Street near Holbrook Avenue.

10200 Club: 1960s, on Dequindre Street. Formerly Skawski's Bar. Sophie Skawski ran it.

Orchid Bar: 1960s, on Jos. Campau Avenue.

Paycheck's Lounge: Forever, on Caniff Street.

Polka Bar: 1960s-1970s, on Jos. Campau Avenue, Cass Chojnacki, prop.

Port Bar: 1960s-2000s, on Jos. Campau. Moved from Jos. Campau Avenue near Holbrook to Jos.
 Campau Avenue across from Florian and Poland streets.

The Polka Bar: 1960s, on Conant Street. "Air-conditioned." That was a big deal then.

Robin's Nest Inn: Inside the notorious Berkshire Motel across from Dodge Main, 1960s-1970s.
 Infamous for the number of prostitution raids conducted there.

Rodic's (Café) Bar: 1970s, on Evaline Street.

Roosevelt Café: 1940s-1980s, on Caniff Street.

2nd Precinct Lounge: 1980s, on Jos. Campau's South End.

Senate Café: Decades on Jos. Campau Avenue. Polkas anyone?

7 Brothers Bar: 1990s-2016 on Jos. Campau Avenue.

Shadow Bar: 2000s, on Jos. Campau Avenue.

Shananigan's: 2000s, on Carpenter Street. In the 1940s it was Pete Kubert's place. His murder there in 1942 shocked the whole city.

Shy & Red's Bar: 1960s-1980s, on Dequindre Street.

Silver Dollar Saloon: 1970s-1980s, on Conant Street.

Stach's Café Club: 1960s, on Conant Street. "Delicious seafood."

Stitch's Bar: 1960s, on Conant Street, formerly Airport Bar.

Stubby's Café: 1960s, on Conant Avenue.

Sunset Café: 1940s-1960s, on Conant Street at the corner of Hanley Street. Felix Mroz ran it.

Suzy's Bar: 2000s, on Evaline Street at Mitchell Street. Formerly Bristol Bar. A really friendly place.

Swinging City Lounge: 1970s-1980s, on Jos. Campau Avenue. Legendary music spot run by Teddy Abraham.

Tam's Lounge: 1970s, on Caniff Street.

Tardie's Bar: 1940s-1980s, on Caniff Street.

Ted's Vee-Jay Bar: 1940s-1960s, on Dequindre Street.

Tek Bar: 1960s, on Yemans Street.

Thomas Patrick's Pub: 1980s, on Conant Avenue, Tom McManus, prop.

Tight Fittin' Jean's Bar: 1990s-2000s, on Jos. Campau Avenue.

Tone's Bar: 1970s, on Caniff Street, John Lamerato, prop.

Tony's Bar: 1940s-1970s, on Jos. Campau Avenue at Danforth Street. Tony Janyk, prop.

Tony's Tavern: 1960s, on Sobieski Street at Commor Street.

Trixies: 2000s, on Carpenter Street.

Trojka, Bar: 1960s, on Jos. Campau Avenue.

Vasil's Bar: 1930s-1972, on Jos. Campau Avenue. Had a string of owners in its long life, including Common Councilman Vasil Vasileff. It burned.

Waiting Room Lounge: 1980s, on Carpenter Street.

Whiskey in the Jar: 2000s. Mayor Tom Jankowski's welcoming place. Formerly Mr. P's.

White Star Bar: 1970s, on Conant, "Disco dancing."

Will's Bar: 1940s-1980s, on Carpenter Street.

Workman's Bar: 1960s, on Miller Street between Jos. Campau and Conant streets.

LAST CALL?

So what's on tap?

I mean, where are we going? No, not to another bar. I think we've gone to enough of them for now. I mean, what's going to happen to the bar scene in Hamtramck?

There are about 35 bars in town now, in 2017, far less than there were at the high point (so to speak). And it doesn't look like many more are headed this way. You have to face the future. The continuing influx of immigrants is shifting Hamtramck to a majority Muslim population, and Muslims forbid the use of alcohol. So if they take the majority of all elected offices of the city government, chances are they will not view the approval of liquor licenses favorably, although everyone, regardless of race or religion, seems to recognize the important role bars continue to play in Hamtramck.

But does it even matter?

The bar music scene isn't what it used to be. The Attic Bar with it legendary blues tunes is a memory. Same goes for Lili's.

Even the polkas no longer play at the Senate Café, which is also gone.

At one time the bars opened at 7 a.m. and at least some of the regulars were smashed by 9 a.m. Now the bars open at 4 or 6 p.m. and with the toughening of drunk driving laws in recent years, most people think carefully of what they are going to do before they step into a bar. (It's too late to think about anything if they stumble out.)

Finding a balance of drinking and somehow getting home hasn't been easy. As one acquaintance of Our Friend, the Drinker told him about drinking and driving: "When you're too drunk to walk, how else are you gonna to get home?"

Ok, not everyone thought that was funny. In 1967 the American Automobile Association—better known as Triple A—came up with the campaign, "First a Friend, Then a Host."

"We don't condone mixing alcohol and driving," said Chester Christy, Hamtramck AAA branch manager. "But we are recognizing that 80 percent of motorists do drink and drive.

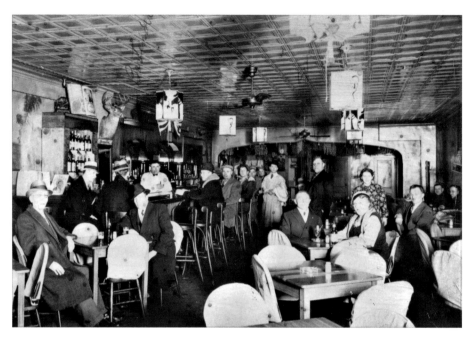

Sam's Café was one of the iterations of the building that was known as Columbia Bar, Lili's, and Painted Lady through the decades.

That is why we are running this campaign at helping hosts and bartenders to encourage them not to let guests overindulge before getting behind the wheel."

It was a good try, and was successful if you look at the numbers. There were 25,000 driving accidents nationally involving alcohol in 1970. By 2016 that was down to about 10,000 accidents.

And maybe the way of the future is in a building so old it doesn't look as though it sports a single straight line anywhere in its ancient frame. It's our old friend, Lili's on Jacob Street. It started out as a village saloon probably in the 19th century. Over the years it evolved into a speakeasy, then was Sam's Cafe, Columbia Bar, Lili's and now, that is to say, in 2017, The Painted Lady. The music isn't nearly as loud as it used to there. In fact, these days the patrons seek a quieter venue.

"It's probably more like it was in the old days," said Andrew Dow, who bought the building in 2004, after Lili's closed. "Things have changed a lot." Patrons now want a comfortable place to sip their whiskey. And they do appreciate the drinks. People don't just slog it down just to get mind-numb. They enjoy the nearly 100 brands he keeps behind the bar.

The music still plays in many places, but "it's reached the saturation point," Dow said.

Suzy Briskey, owner of Suzy's Bar on Evaline Street at the corner of Mitchell Street, agrees. Her place is like a "family" place in a small town, she said. She and her friends

Above left: These days, the music scene has faded and the emphasis has shifted back to making bars cozy, welcoming places. Suzy Briskey, owner of Suzy's Bar, has built a comfortable corner retreat.

Above right: The music has toned down a lot these days, says Andrew Dow, owner of Painted Lady Bar. Patrons now are looking for a place to relax rather than be blasted by music.

"love the hospitality."

Are bars showing their gentler side? Have we all gone soft?

All this was enough to make Our Friend, the Drinker drop his head onto the table. The kitchen table. It was last night that he was in the bar. He doesn't remember much, which is a sure sign that he had a great time, but at least he was smart enough to go home safely with a designated driver. That even eased the concern of the bartender, who was assured that his customer would get home alive.

Times sure have changed, he thought, between the throbs that choked his brain. Back in the old days, he'd just suck it up and bear the pain, which would gradually ease in time for him to head back to the bar. Now he knew his days of over indulgence were indeed over.

And that is fine with the bars. They don't want trouble. They just want to be places were people come to have fun together.

And maybe that is the shining light of the future for the corner bar, for so long as people want to have fun, bars are going to be there.

One way or another.

BIBLIOGRAPHY

Brooks, Tim and Marsh, Earle, *The Complete Directory to Prime Time Network TV Shows,* 1946-Present, Ballantine Books, New York, 1992.

Farmer, Silas, *The History of Detroit and Michigan*, Silas Farmer & Co., Detroit, 1884.

Handlin, Oscar, *The Uprooted: The Epic Story of the Great Migration that Made the American People*, Little, Brown and Company, Boston, 1952.

Hyde, Charles, *The Dodge Brothers: The Men, the Motor Cars, and the Legacy*, Wayne State University Press, 2005.

Hyde, Charles, *Dodge Brothers Motor Car Company Plant*, Historic American Engineering Record, Department of the Interior, Philadelphia, 1980.

Historical Records Survey Project Division of the Profession and Services Projects, WPA Project, *Minutes of the Meetings of the Village Council of Hamtramck, 1907-1908* and *1901*, 1941.

Kavieff, Paul R., *The Violent Years*, Fort Lee, Barricade Books, 2001.

Pittrone, Jean Madden, *Tangled Web: Legacy of Auto Pioneer, John F. Dodge*, Avenue Publishing Company, Hamtramck, 1989.

Radzialowski, Dr. Thaddeus, *St. Florian Parish, 75 Years*, Hamtramck, MI, 1983.

Rarogiewicz, E.W., *Hamtramck Yearbook—1947-1948.* Hamtramck, E. W. Rarogiewicz, 1948.

Serafino, Frank, *West of Warsaw*, Avenue Publishing, Hamtramck, MI, 1983.

Wood, Arthur Evans, *Hamtramck Then and Now: A Sociological Study of a Polish-American Community*, Octagon Books, New York, 1955, 1974.

Newspapers

Various copies of *The Hamtramck Citizen* and the *Detroit Metro Times* were consulted and are cited in the text.